Portrait
Inspirations

A Collection of Drawing and Painting Ideas for Artists

Includes work in:
- Acrylic
- Colored Pencil
- Oil
- Pastel
- Watercolor

First published in the United States of America by:
Quarry Books, an imprint of
Rockport Publishers, Inc.
33 Commercial Street
Gloucester, Massachusetts 01930-5089
Telephone: (508) 282-9590
Fax: (508) 283-2742

Distributed to the book trade and art trade in the United States by:
North Light, an imprint of
F & W Publications
1507 Dana Avenue
Cincinnati, Ohio 45207
Telephone: (800) 289-0963

Other Distribution by:
Rockport Publishers, Inc.
Gloucester, Massachusetts 01930-5089

ISBN 1-56496-383-7

10 9 8 7 6 5 4 3 2 1

Designer: **Frederick Schneider / Grafis**
Cover Images: 42, 48, 50, 52, 76

Printed in Hong Kong.

Portrait
Inspirations

A Collection of Drawing and Painting Ideas for Artists

ROCKPORT PUBLISHERS, INC. • GLOUCESTER, MASSACHUSETTS

DISTRIBUTED BY NORTH LIGHT BOOKS • CINCINATTI, OHIO

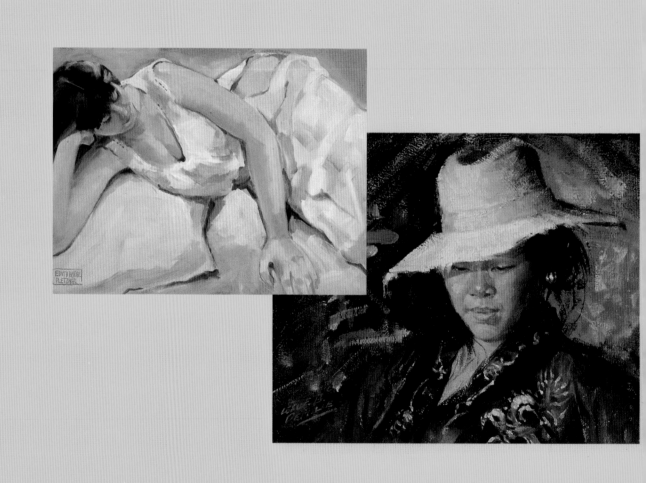

Introduction

A portraitist has a difficult job: the artist must translate the likeness of a person onto a flat sheet of paper. Despite the difficulty, the artists included in this volume have managed to do just that. The faces that appear in these pages are not merely cartoon caricatures of faces, but we, as viewers, are able to see the personality behind each of the subjects.

Many of the paintings found in this volume are not considered formal "portraits." Rather, the range of included work is enormous and the common denominator seems just to be the inclusion of people. By loosely defining what a portrait is and collecting these paintings together, it is possible to see people in every imaginable way. Whether a spontaneous painting of a marketplace, or a formal sit-down portrait, each of these paintings manages to capture the humanity behind the people: their personalities, their emotions, and their actions.

Another unique aspect of this book is the range of media included. A portrait rendered in pastel has a very different effect than a portrait rendered in watercolor. By putting them together, each viewer is able to see the potential of the media and possibly imagine the outcome. It also challenges you as a painter to try new media and see what kind of results you will have.

If you ask twenty painters what the best way to approach a portrait is, you are going to get twenty different answers. Each artist must explore their own talents and their own methods in order to produce the greatest result. We hope this volume will inspire you to live up to your potential and explore the wonderful world of portrait painting.

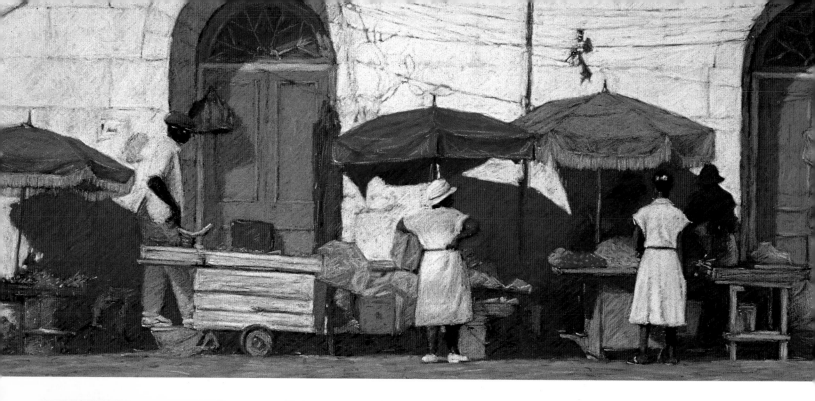

Alice Bach Hyde
Bridgetown Market, Barbados
16" x 34.5" (40.6 cm x 87.6 cm)
Canvas made for pastels

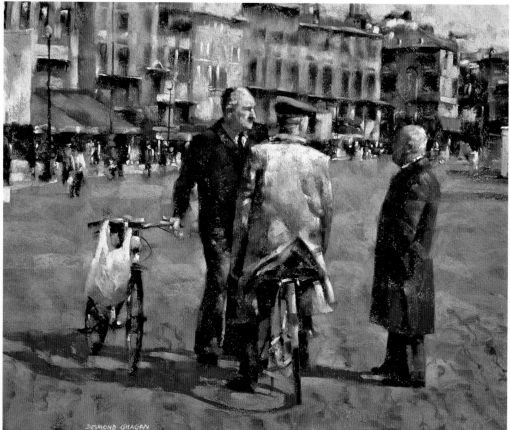

Desmond O'Hagan
Conversation, Verona
18" x 22" (45.7 cm x 55.9 cm)
Canson Mi-Teintes paper

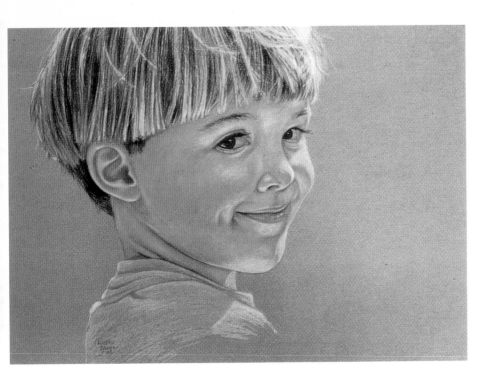

Debra Kauffman Yaun
Kevin's Grin
11" x 13" (28 cm x 33 cm)
Pastel paper

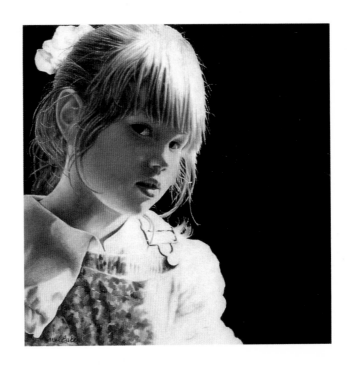

Carol Baker
Britney
18" x 17" (46 cm x 43 cm)
Bristol 2-ply vellum

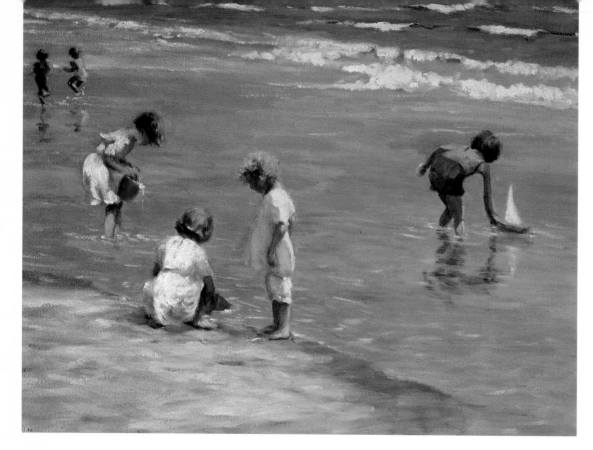

Shirley Cean Youngs
Joy
24" x 30" (61 cm x 76.2 cm)
Linen

Bruce Backman Turner
August Reflections
20" x 24" (50.8 cm x 61 cm)
Canvas

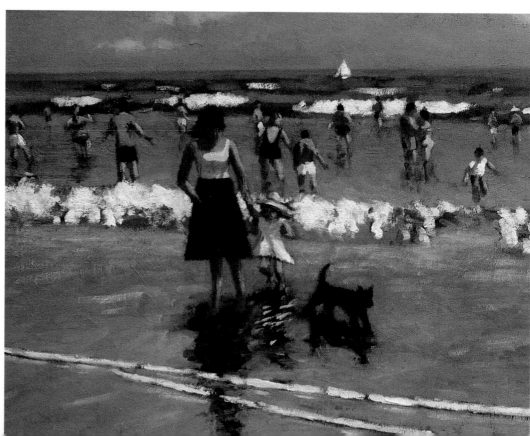

J. Everett Draper, A.W.S.
Mayport Ferry I
10" x 14" (25.4 cm x 36.6 cm)
Arches 140 lb. rough

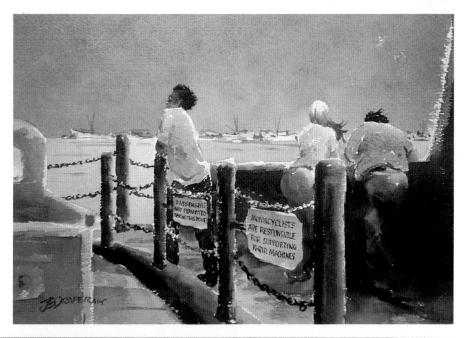

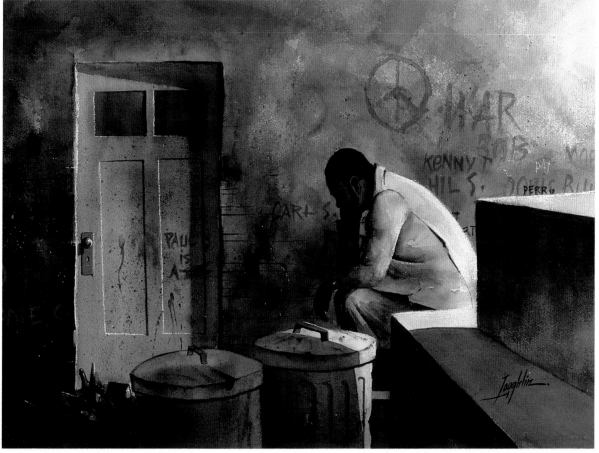

John L. Loughlin
Ghetto Thinker
22" x 30" (55.9 cm x 76.2 cm)
Arches 300 lb. cold press

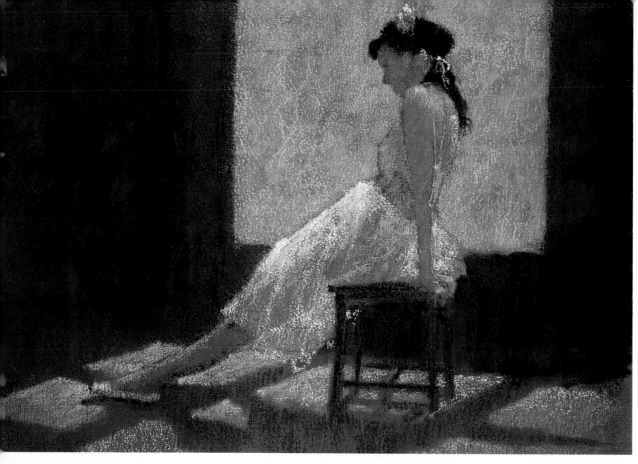

Lilienne B. Emrich
Repose
9" x 13" (22.9 cm x 33 cm)
Pumice-toned art board

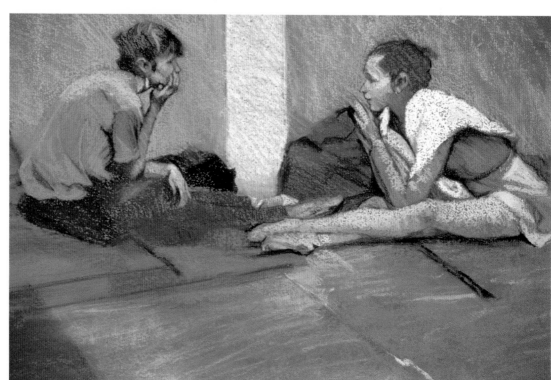

Rhoda Yanow
The Conversation
22" x 28" (55.9 cm x 71.1 cm)
Sanded surface

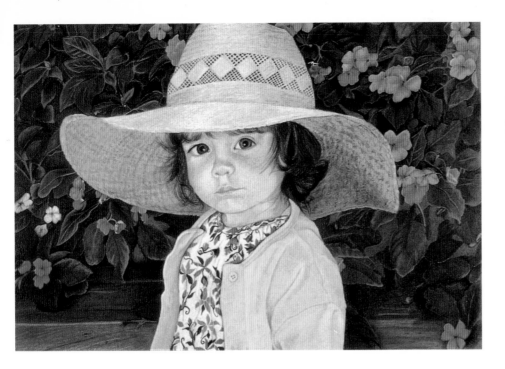

Michele K. Blate
Jenna
20" x 26" (51 cm x 66 cm)
Crescent mat board

Jim Wells
Brandy
22" x 17" (55 cm x 43 cm)
Strathmore bristol board

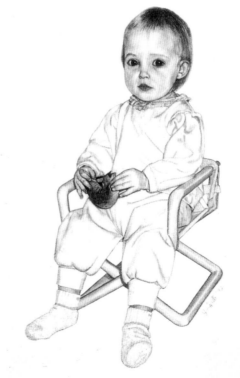

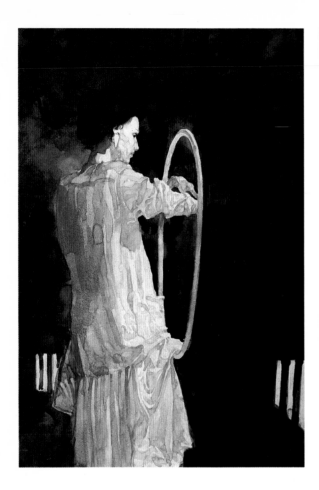

Bill James, A.W.S., P.S.A.
Mannequin With Hoop
33" x 26" (83.8 cm x 66 cm)
Crescent
Media: Gouache

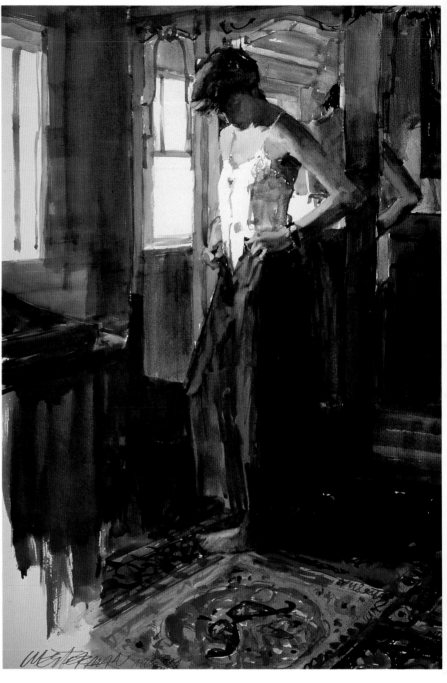

Arne Westerman, A.W.S., N.W.S.
Carol with Antique Wardrobe
37" x 25" (92.5 cm x 62.5 cm)
Lana Aquarelle 140 lb. hot press

Melissa Miller Nece
Tide Pool III
19" x 29" (48cm x 74cm)
Pastel paper

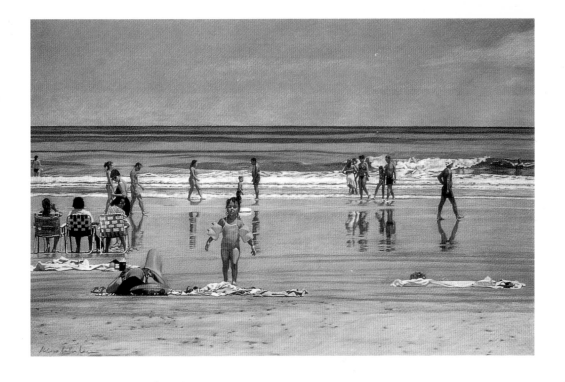

Melissa Miller Nece
Headin' In
18" x 24" (46cm x 61cm)
Canson Mi-Tientes

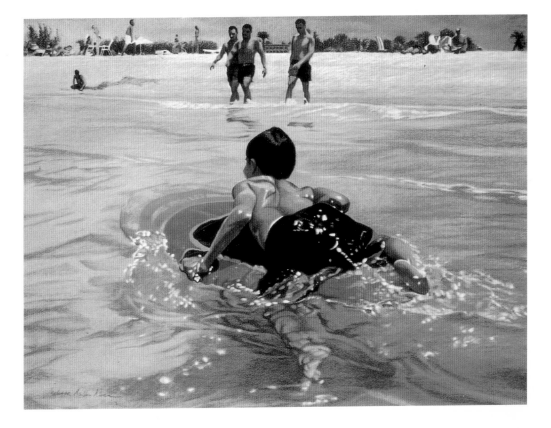

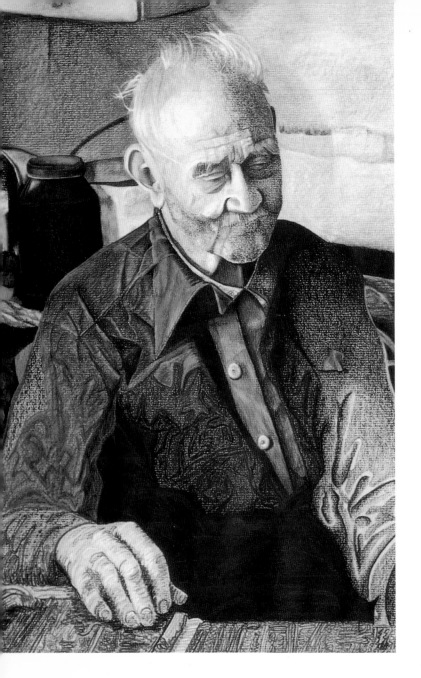

Dr. Christine J. Davis
Reflections: Mr. Center
28" x 22" (71 cm x 56 cm)
Strathmore charcoal paper

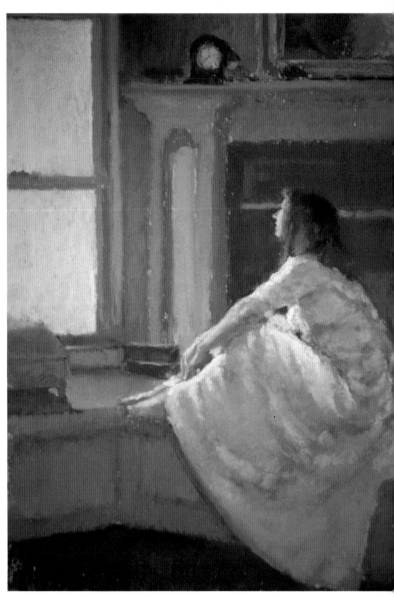

Joann A. Ballinger
In the Light
11" x 7" (27.9 cm x 17.8 cm)
Sandpaper

Bart O'Farrell
Dawn Picking
10" x 14" (25 cm x 36 cm)
Canvas

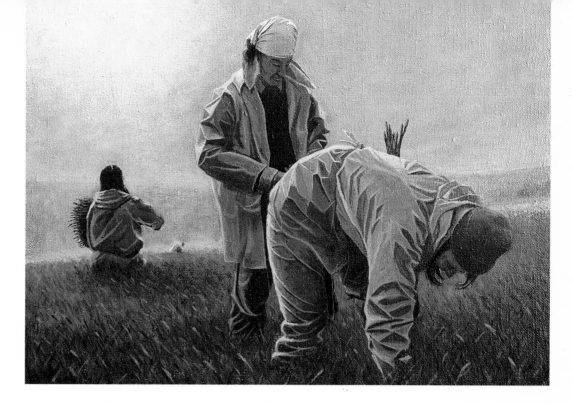

Bart O'Farrell
In the Daffodil Fields
36" x 48" (91 cm x 122 cm)
Canvas

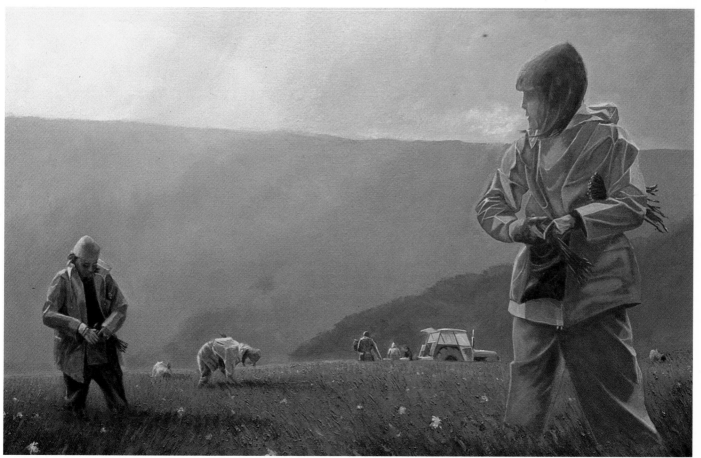

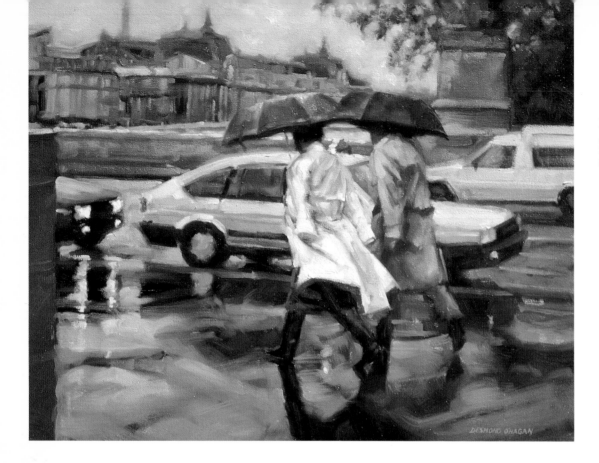

Desmond O'Hagan
After the Storm, Paris
24" x 30" (61 cm x 76.2 cm)
Canvas

D. Wels
Passengers Boarding
28" x 48" (71.1 cm x 121.9 cm)
Canvas

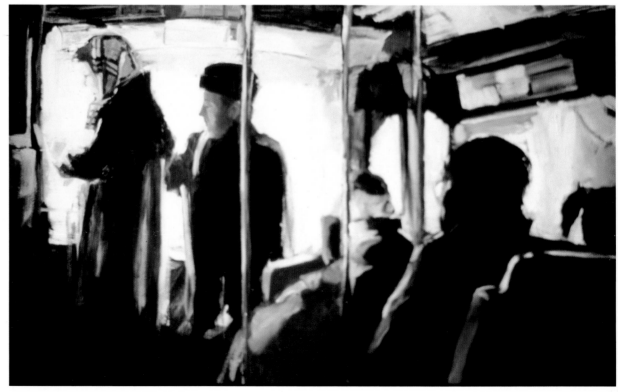

Karen Frey
Boy with Blue Cap
14" x 20" (35.6 cm x 50.8 cm)
Lana Aquarelle 140 lb. rough

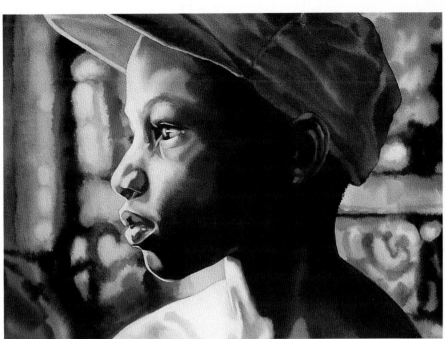

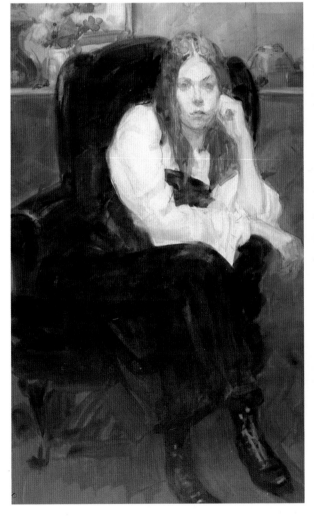

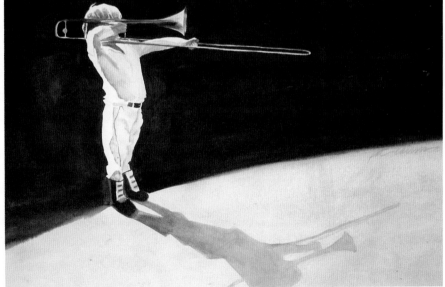

Pat Cairns
Music Man
22" x 30" (55.9 cm x 76.2 cm)
Arches 140 lb. hot press

Irwin Greenberg
Madeline
11" x 7" (27.9 cm x 17.8 cm)
Bristol 3-ply plate

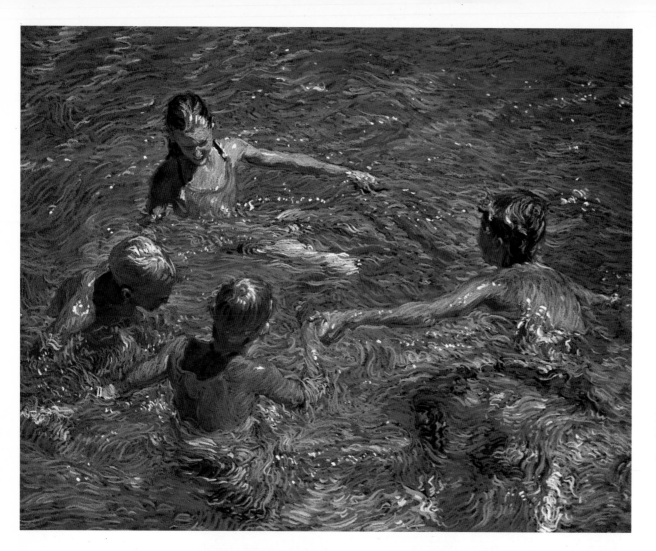

Bill James
Kids in Pool
19" x 22" (48.3 cm x 55.9 cm)
Canson Mi-Teintes paper

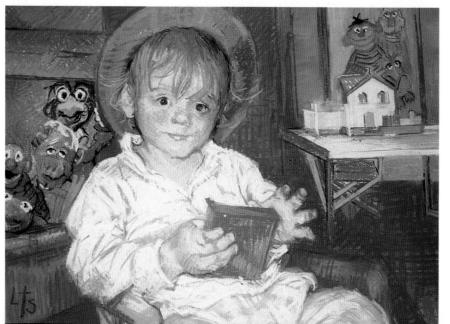

Lucille T. Stillman
Richard Peter
20" x 25" (50.8 cm x 63.5 cm)
Canson Mi-Teintes paper

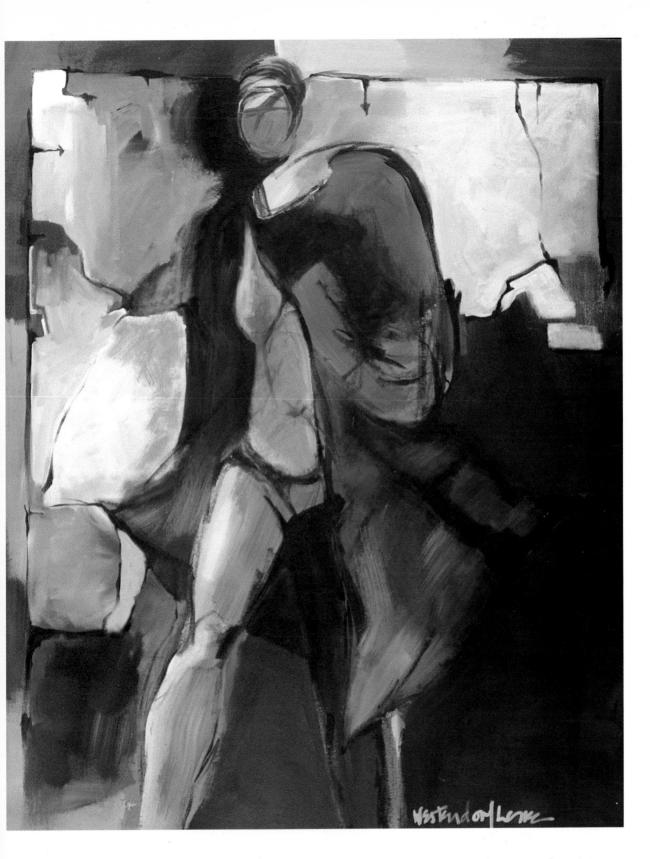

Ellen Westendorf Lane
Stepping Out
46" x 38" (117 cm x 97 cm)
Canvas

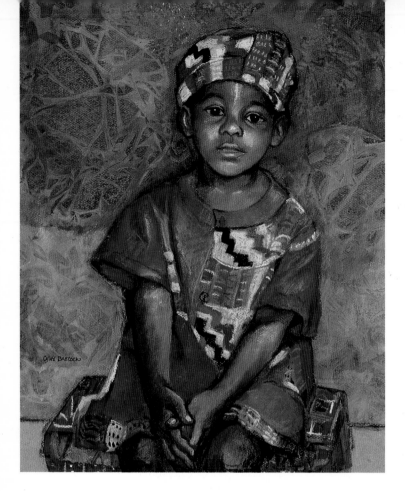

Cathy Babcock
My Little Friend Terry
20" x 16" (50.8 cm x 40.6 cm)
Pastel with watercolor
Canson board

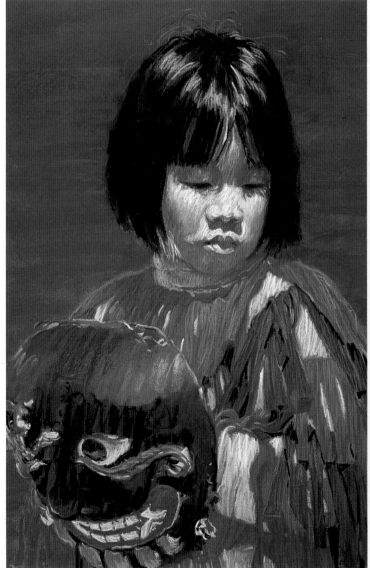

Bill James
The Green Mask
28" x 25" (71.1 cm x 63.5 cm)
Pumice board

George James
Away From the Wind
25" x 38" (63.5 cm x 96.5 cm)
Synthetic Kimdura 140 lb. hot press

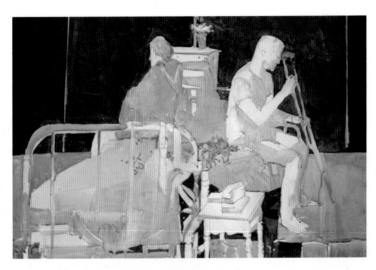

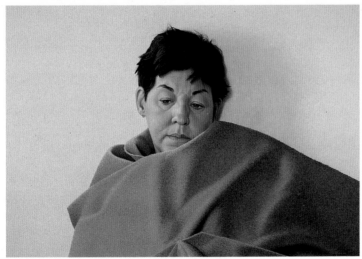

Joseph Manning
Until Death Do Us Part
17.25" x 23.5" (43.8 cm x 59.7 cm)
Gesso on illustration board
Media: Egg tempera, watercolor

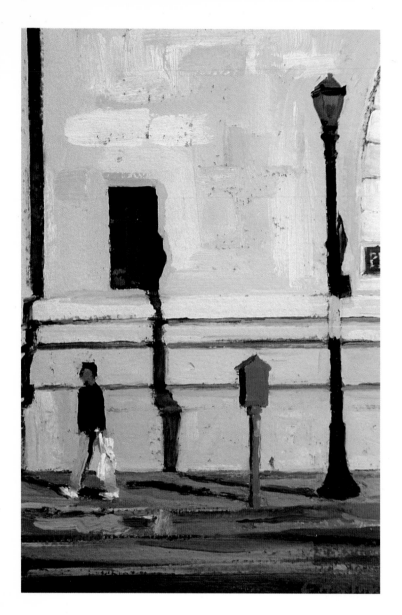

Christine Hanlon
Embarcadero
9.5" x 6.5" (24.1 cm x 16.5 cm)
Gesso-primed medium weight paper

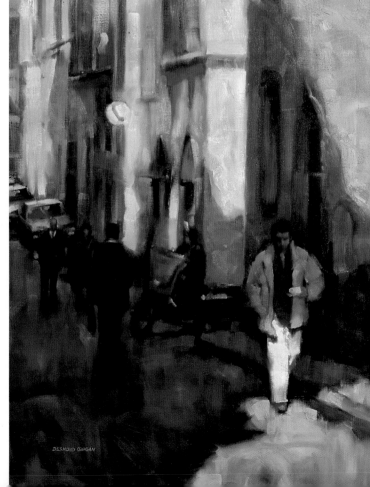

Desmond O'Hagan
Fall Shadows, Florentine Street
40" x 30" (101.6 cm x 76.2 cm)
Canvas

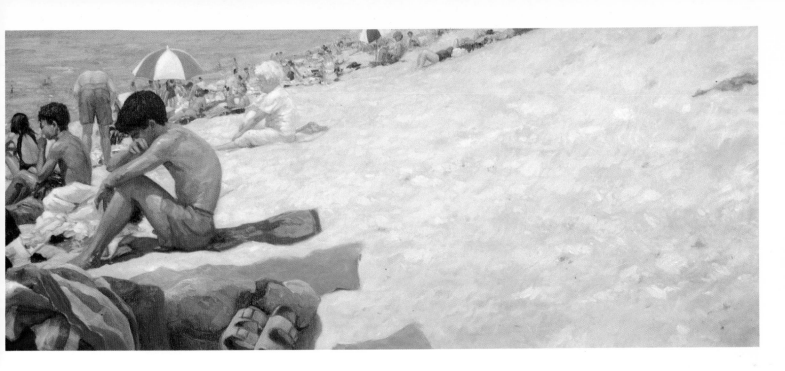

Debra Reid Jenkins
Birks at K.P.
24" x 60" (61 cm x 152.4 cm)
Oil with hide glue and white lead
Canvas

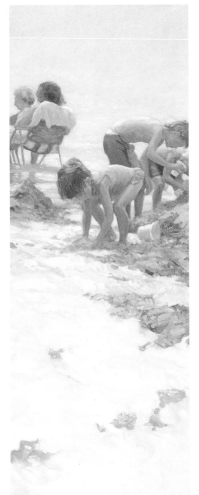

Debra Reid Jenkins
Busy Day
40" x 16" (101.6 cm x 40.6 cm)
Oil with hide glue and white lead
Canvas

Faith Wickey
Grandma Miller
12" x 9" (30 cm x 22 cm)
Cold press illustration board

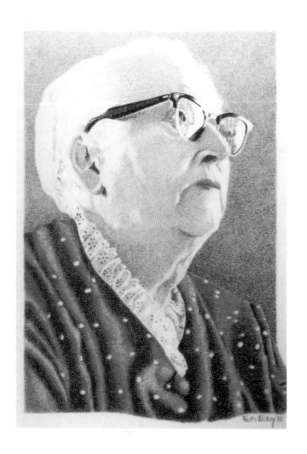

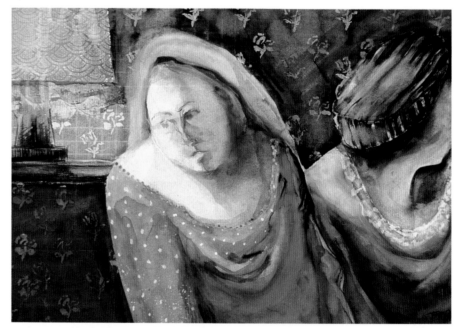

Paula Temple
Visiting Sister
24" x 36" (60.9 cm x 91.4 cm)
Morilla
*Media: Collage of textured rice
paper, gold sticker dots*

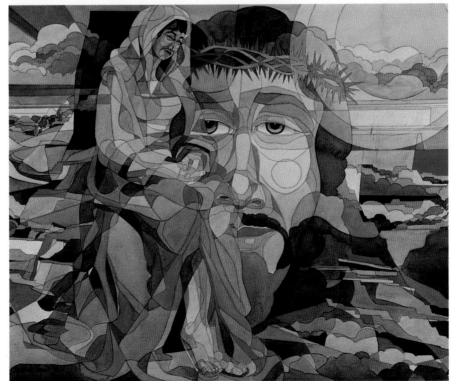

Colleen Newport Stevens
Los Amigos
22" x 30" (55.9 cm x 76.2 cm)
Lana Aquarelle 555 lb.

Jospeh E. Grey II
The Pieta
16" x 22" (40.6 cm x 55.8 cm)
Arches 140 lb. cold press

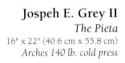

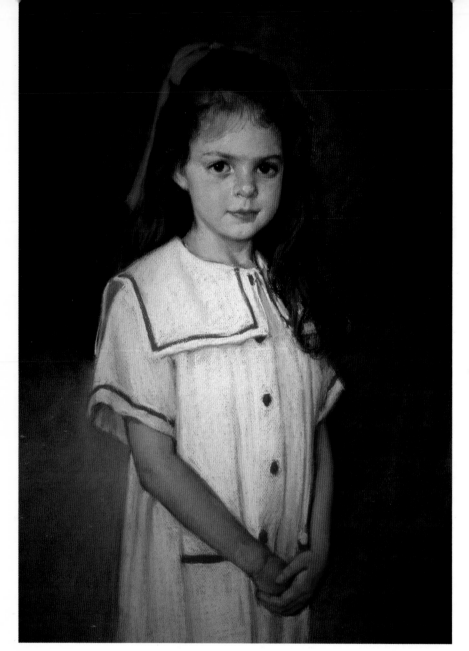

Mitsuno Ishii Reedy
Claire
24" x 20" (61 cm x 50.8 cm)
Canson Mi-Teintes paper

Maggie Goodwin
Navajo Boy
10" x 7" (25.4 cm x 17.8 cm)
Ersta paper

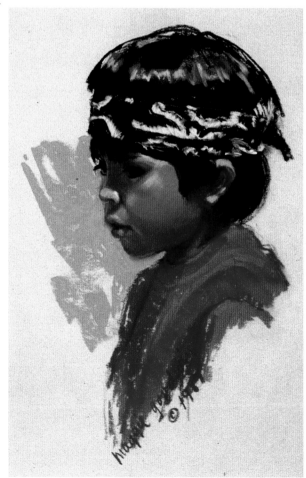

Charlotte Wharton
Little Boy Blue
21" x 15" (53.3 cm x 38.1 cm)
Canson paper

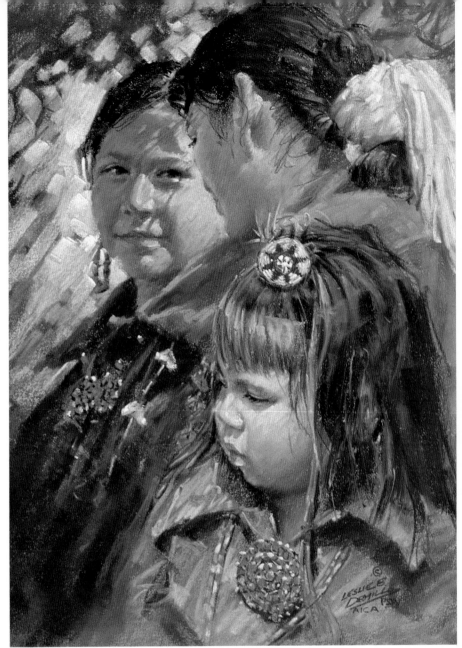

Leslie B. De Mille
#1620 Teen Secrets
23.5" x 16" (59.7 cm x 40.6 cm)
Canson paper

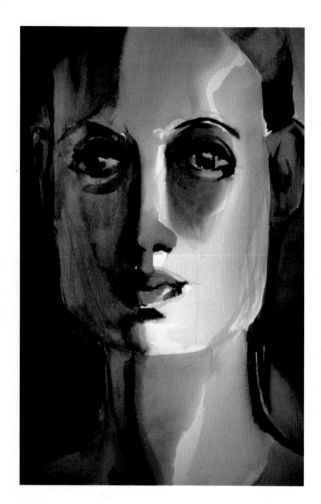

Lance R. Miyamoto, N.W.S.
Sibyl (Persian)
24" x 19" (60.9 cm x 48.3 cm)
Arches 140 lb. rough

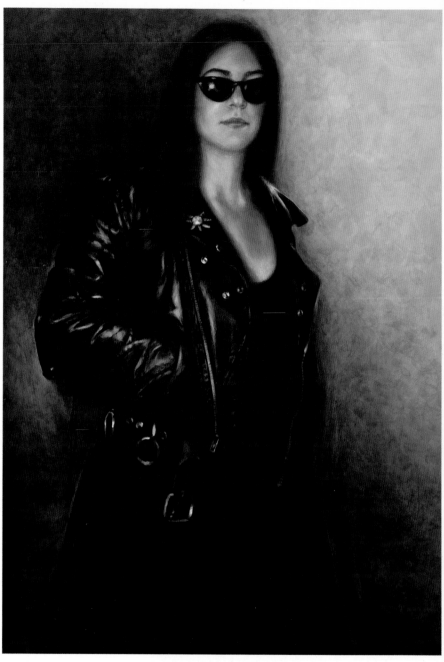

Jane Bregoli
Crepuscule in Black & Brown: Wendy
40" x 30" (101.6 cm x 76.2 cm)
Strathmore 4-ply bristol hot press medium surface

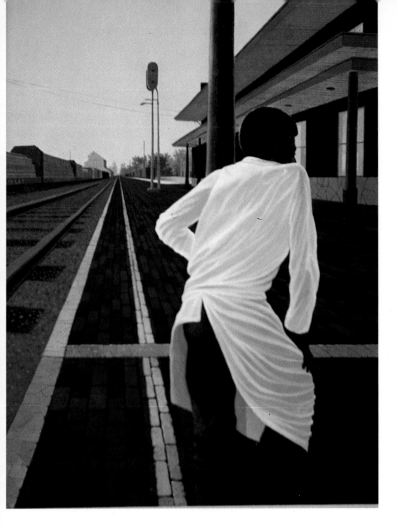

Rolland Golden
All Tracks Lead to New Orleans
40" x 30" (102 cm x 76 cm)
Canvas

Petr Liska
Moment at Marienbad
36" x 24" (91 cm x 61 cm)
Canvas

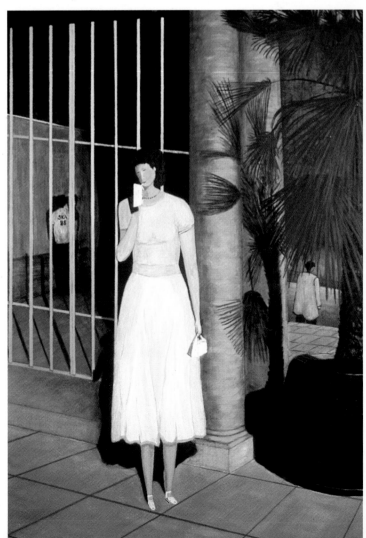

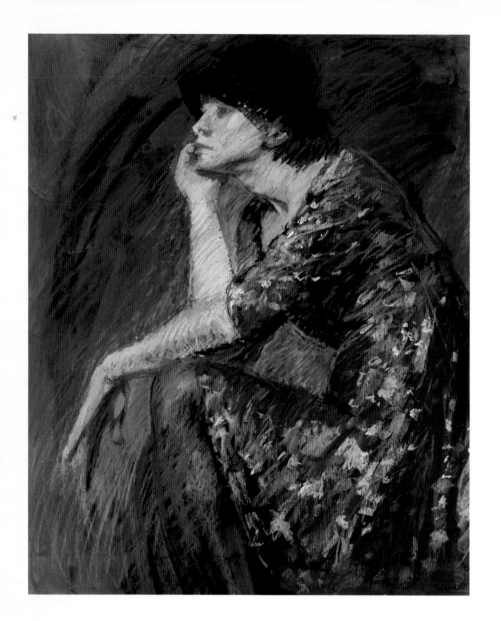

Mikki R. Dillon
The Flowered Dress
27" x 21" (68.6 cm x 53.3 cm)
Ersta sanded paper

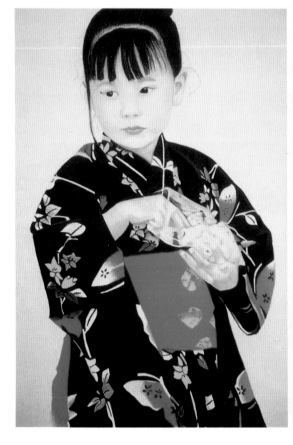

Tim Ernst
Popcorn Girl
28" x 19" (71 cm x 48 cm)
Bristol 3-ply vellum

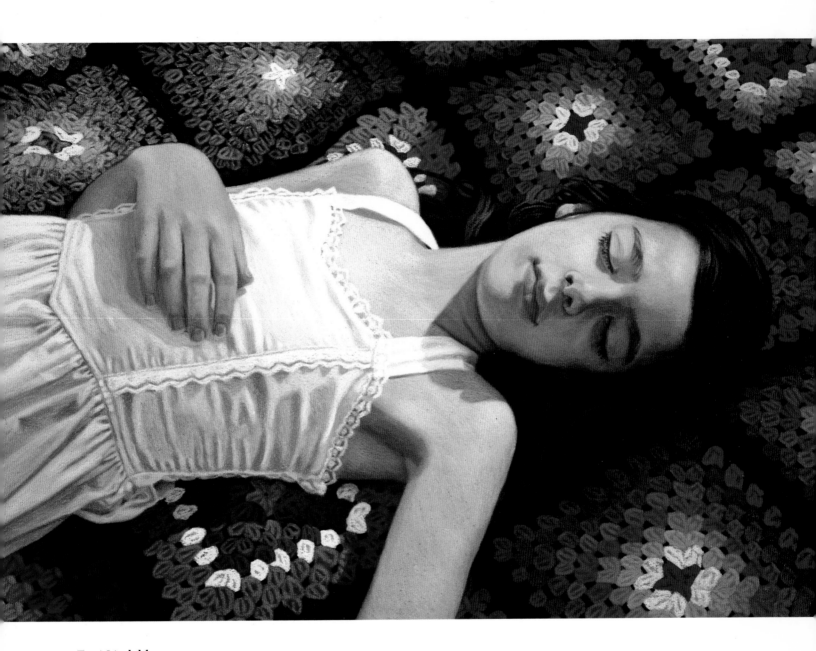

Toni Lindahl
Repose
20" x 30" (50.8 cm x 76.5 cm)
Arches 140 lb. watercolor paper

Anita Meynig
Pop-The-Whip
10" x 22" (25.4 cm x 55.9 cm)
Arches 140 lb. cold press
Media: Watercolor, ink

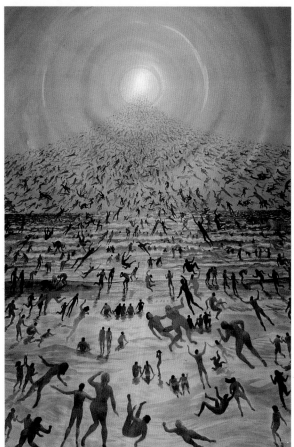

Michael Frary
Factory Recall
42" x 30" (106.7 cm x 76.2 cm)
Arches Imperial 140 lb. cold press

Ann James Massey
Henri Berenger
10" x 8" (25 cm x 20 cm)
Bristol paper

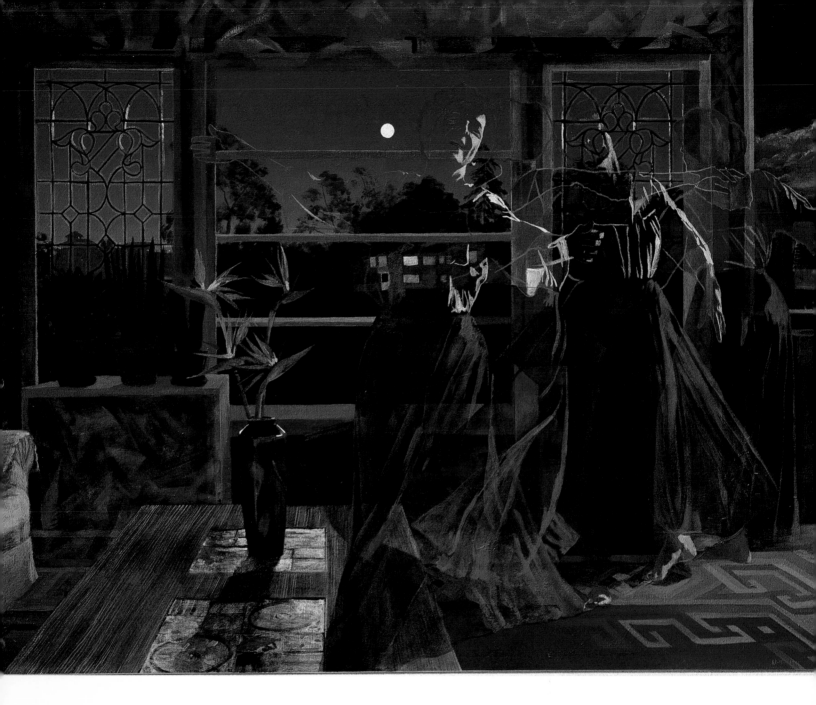

Lawrence Wallin
Moonlight Nocturne
36" x 48" (91 cm x 122 cm)
Canvas

Parima Parineh
Untitled (2)
25" x 20" (63.5 cm x 50.8 cm)
Canson Mi-Teintes paper

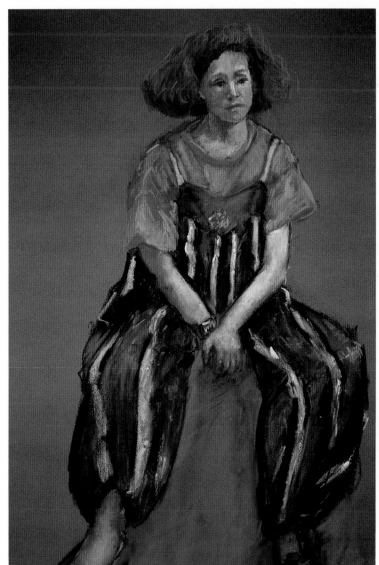

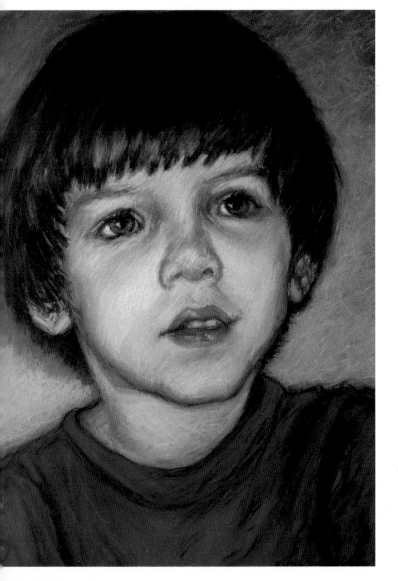

Beatrice Goldfine
Joey
25.5" x 19.5" (64.8 cm x 49.5 cm)
Canson pastel paper

Donna Basile
Shirley
16" x 19" (41 cm x 48 cm)
100% rag mat board

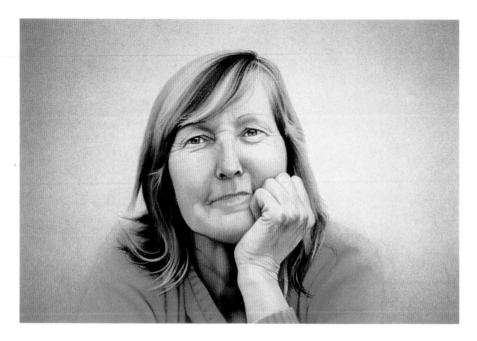

D. J. Hansen
Sunday Afternoon
25" x 19" (64 cm x 48 cm)
Canson Mi-Tientes 98 lb. paper

Dixie Smith
One
27" x 18" (69 cm x 46 cm)
Rising Stonehenge

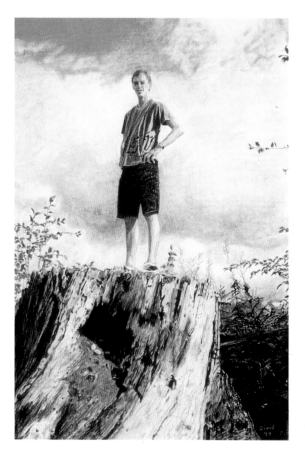

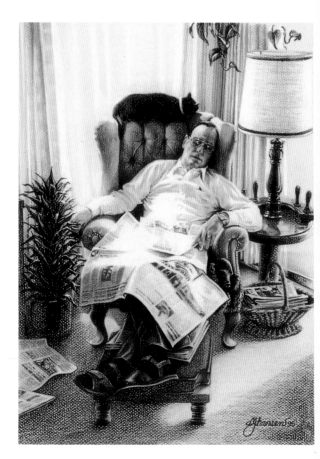

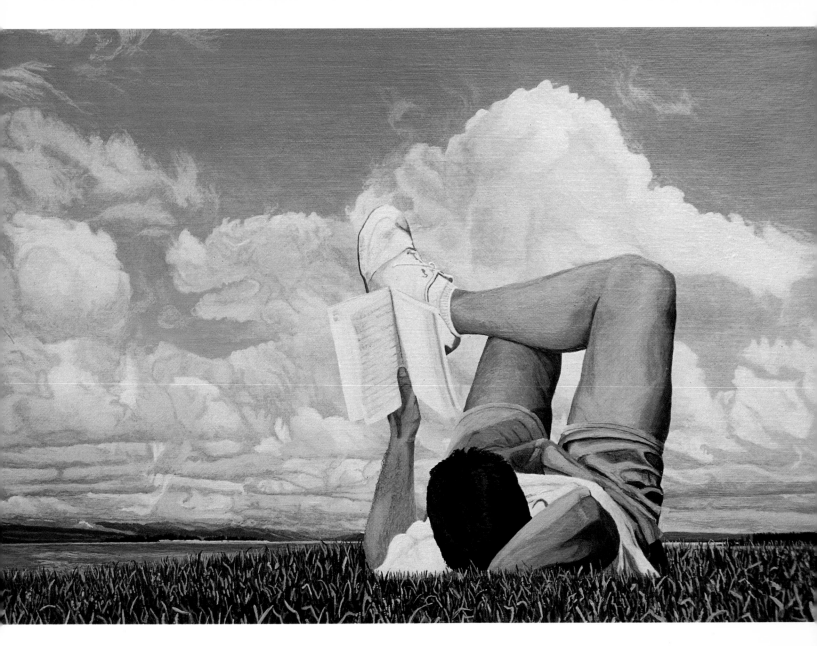

Tim Flanagan
Beyond Boundaries
12" x 18" (30 cm x 45 cm)
Canvas

Janis Theodore
Young Man/Old Map
28" x 22" (71.1 cm x 55.9 cm)
Pastel sandpaper

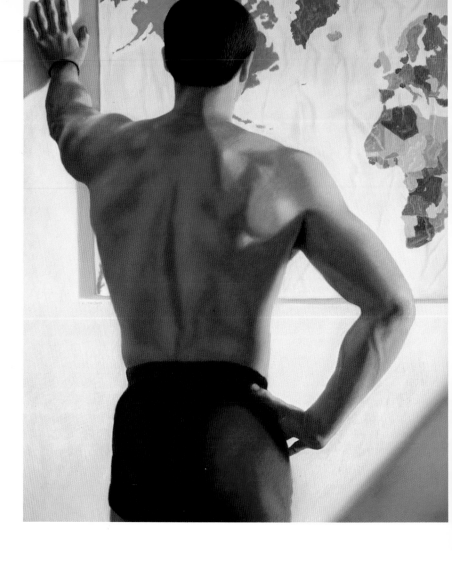

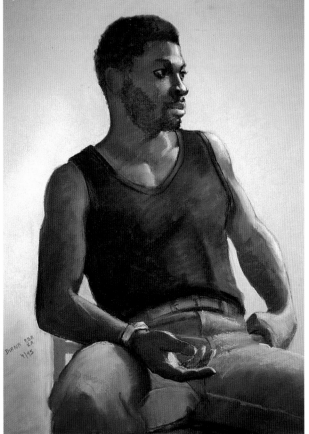

Diana De Santis
Tyrone
36" x 28" (91.4 cm x 71.1 cm)
Gesso-primed Arches 4-ply board

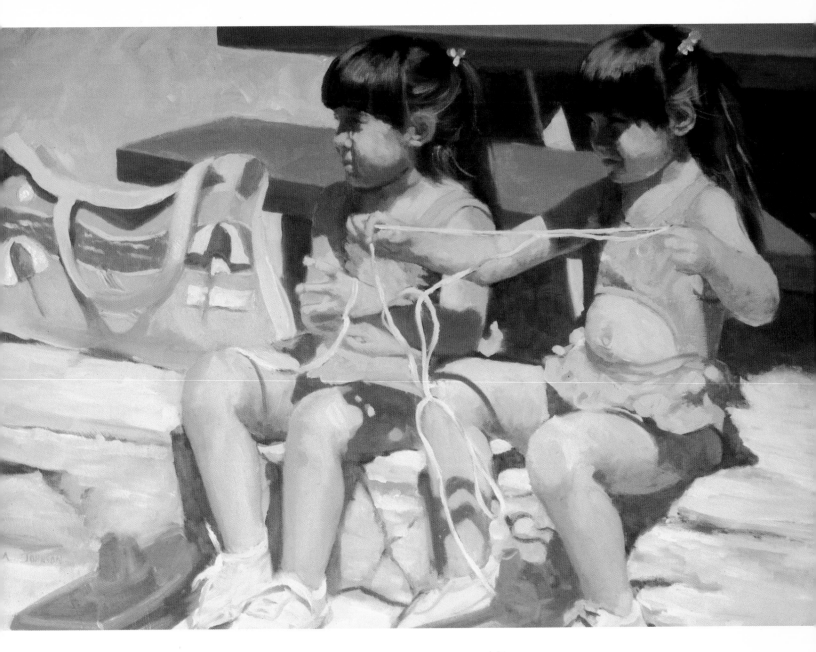

Sandra A. Johnson
Patiently Waiting
30" x 40" (76.2 cm x 101.6 cm)
Gesso-primed watercolor board

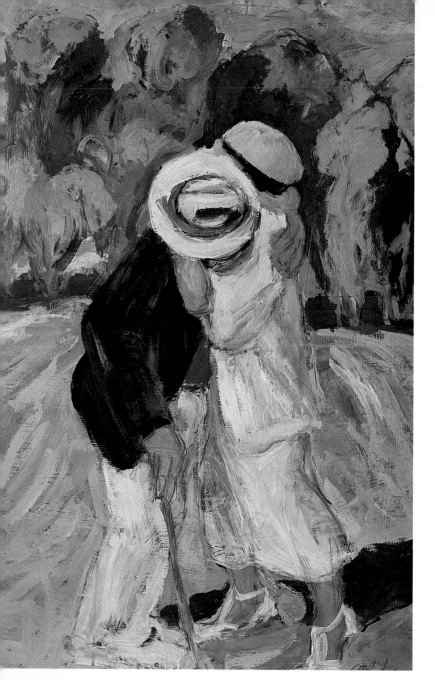

A. M. Lawtey
Sunday Afternoon Croquet
38" x 24" (94 cm x 61 cm)
Acrylic with watercolor crayon
Cover weight oak tag

Gordon Carlisle
Spirit of America
55" x 48" (140 cm x 122 cm)
Constructed plywood surface

Ann T. Pierce
The Mime
21.5" x 29.5" (54.6 cm x 74.9 cm)
Arches 140 lb. rough
Media: Transparent watercolor,
watercolor crayon, acrylic gel background

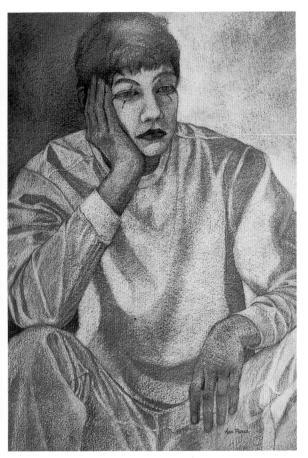

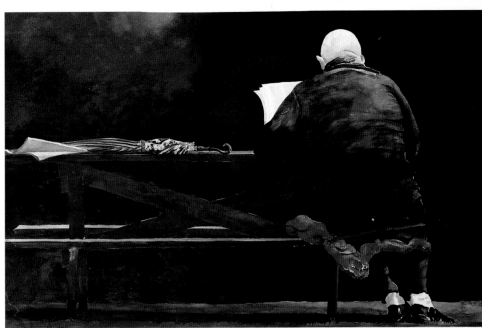

Jerry M. Ellis, A.W.S., N.W.S.
Mr. Clean
19" x 28" (48.3 cm x 71.1 cm)
Arches 260 lb. cold press

Edith Hodge Pletzner
Patchwork
18" x 24" (46 cm x 61 cm)
Canvas

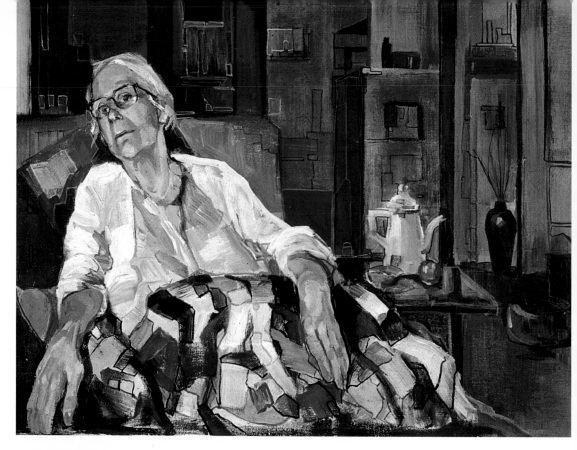

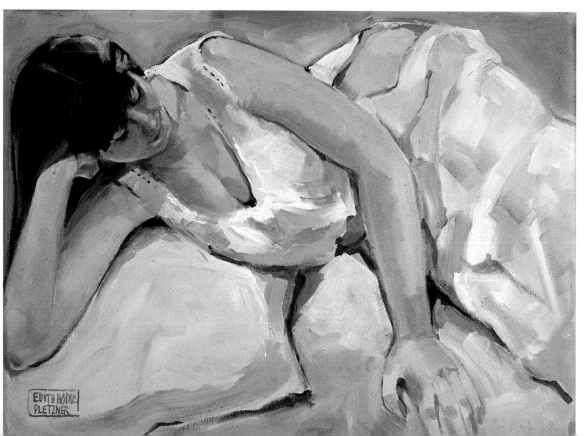

Edith Hodge Pletzner
Victorian Slip
18" x 24" (46 cm x 61 cm)
Canvas

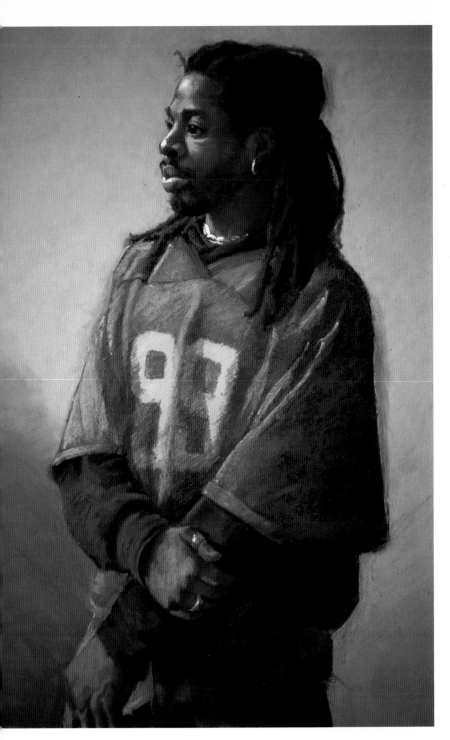

Diana De Santis
Renee 99
36" x 28" (91.4 cm x 71.1 cm)
Gesso-primed Arches 4-ply board

Rhoda Yanow
Rehearsal
26" x 22" (66 cm x 55.9 cm)
Sanded surface

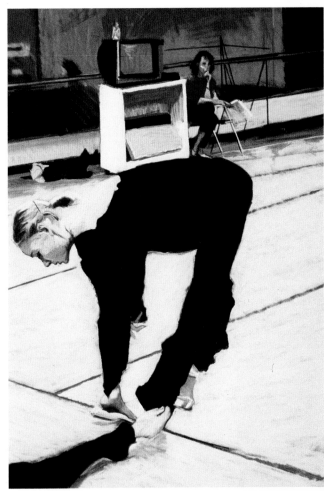

43

Jeanette Martone
At Bomet
28" x 18" (71.1 cm x 45.7 cm)
Canvas

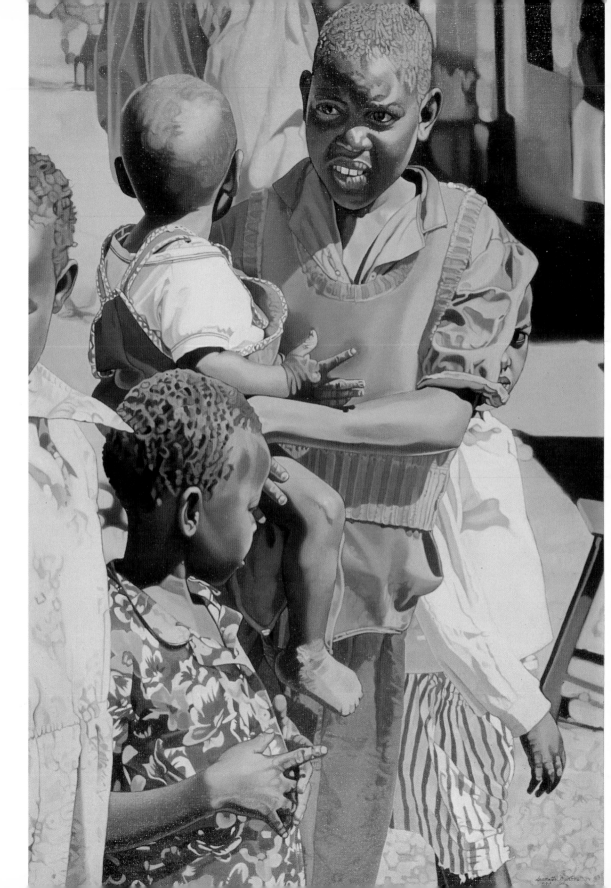

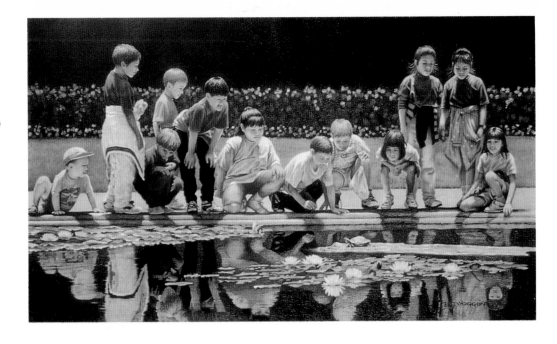

Brenda Woggon
The Field Trip
17" x 30" (43 cm x 76 cm)
Windberg art panel

Marvin Triguba
Night Watch
21" x 17" (53 cm x 43 cm)
Canson paper

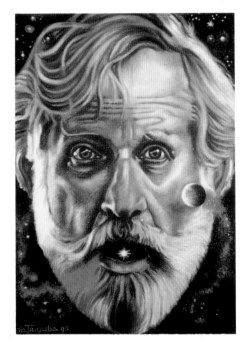

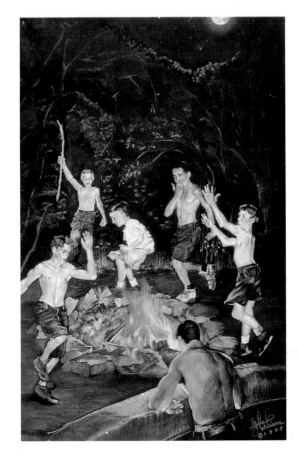

Linda Hutchinson
Joy Dance, Boy Dance
40" x 30" (102 cm x 76 cm)
Black illustration board

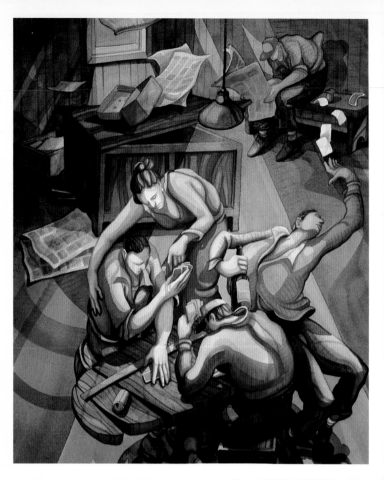

Robert L. Barnum
Down Time
19" x 24" (48.3 cm x 60.9 cm)
Arches 300 lb. rough

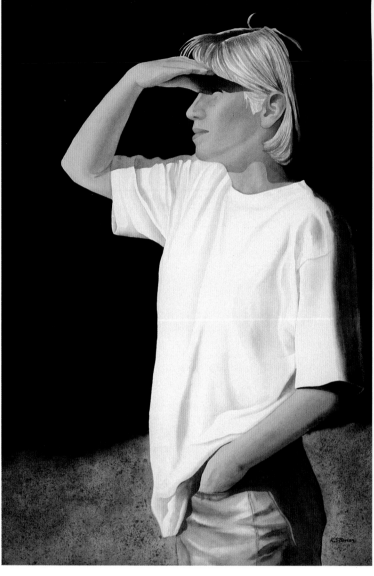

Kim Stanley Bonar
Into The Light
30" x 22" (76.2 cm x 55.9 cm)
Arches 300 lb. cold press

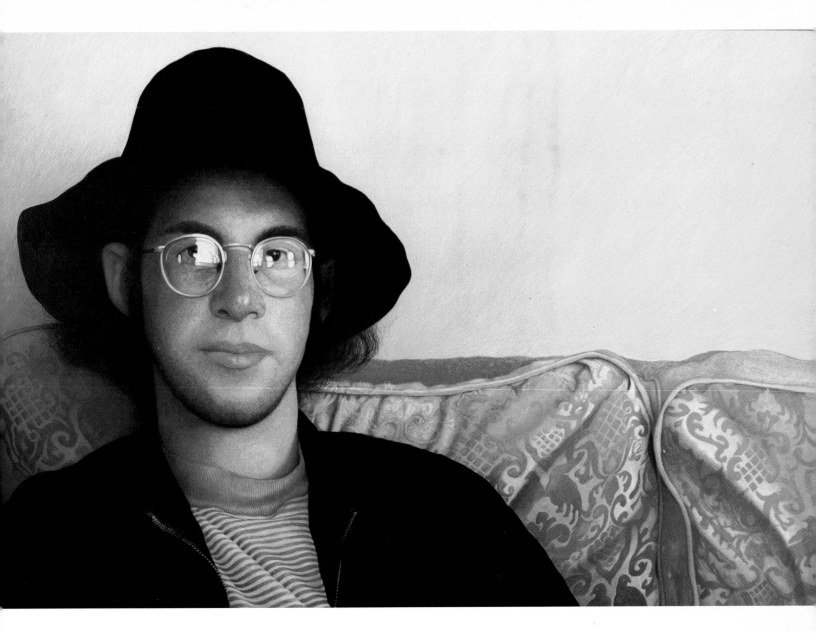

Douglas Wiltraut
The Visitor
22" x 34" (56 cm x 86 cm)
Masonite gesso-coated panel

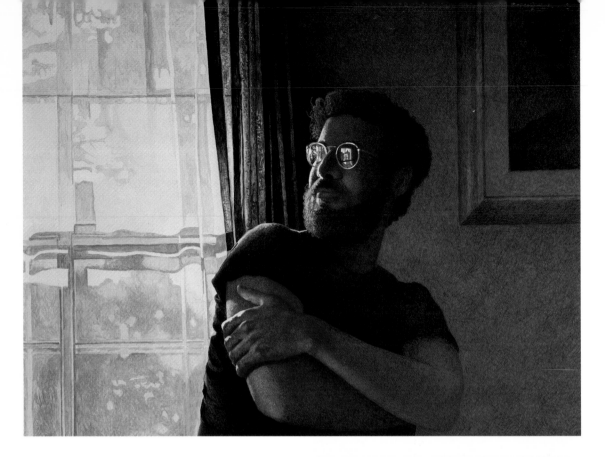

Douglas Wiltraut
Looking Toward Evening
21" x 27" (53 cm x 69 cm)
Masonite gesso-coated panel

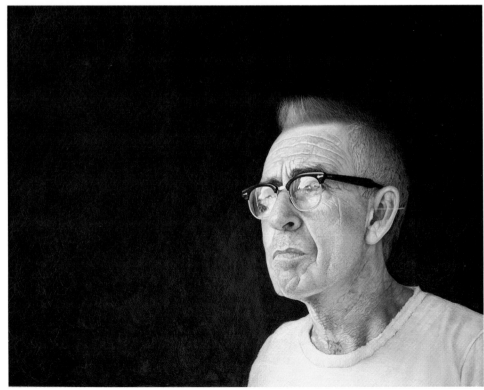

Douglas Wiltraut
Vintage
23" x 29" (58 cm x 74 cm)
Masonite gesso-coated panel

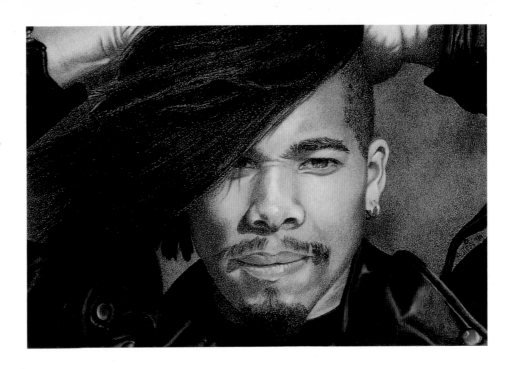

Bonnie Auten
Brannon
9" x 13" (23 cm x 33 cm)
Windberg pastel paper, grey

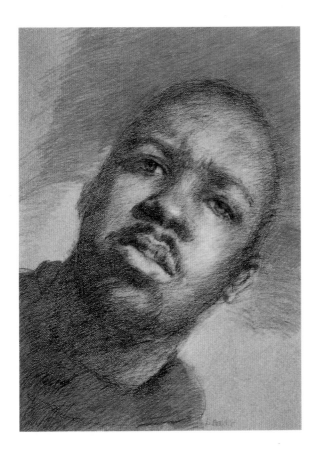

Linda Baxter
Rap Star
30" x 24" (76 cm x 61 cm)
Canson paper

Charlotte Wharton
Beth and Angela Quitadamo
(Portrait)
48" x 37" (121.9 cm x 94 cm)
Canvas

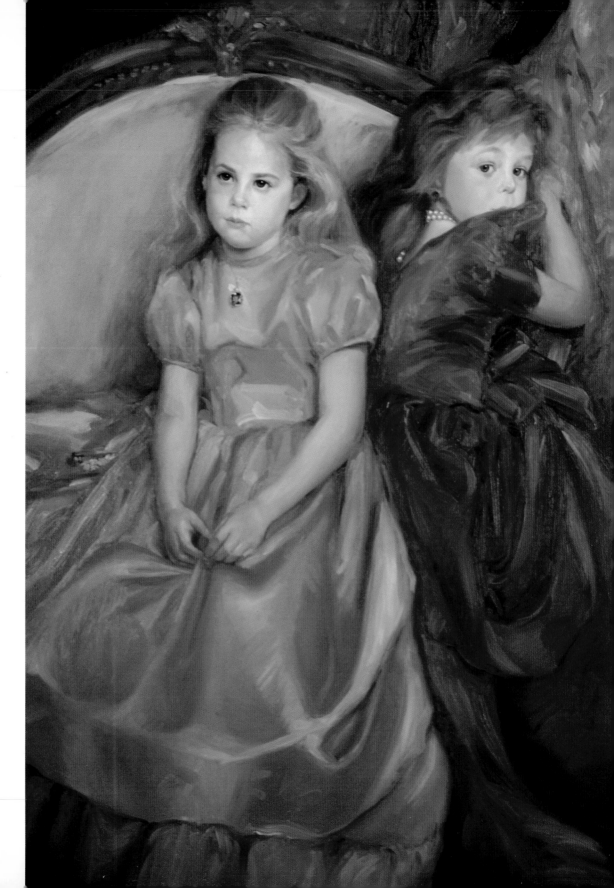

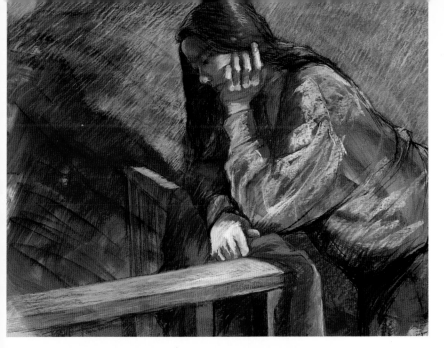

Junko Ono Rothwell
Looking Over the Bannister
21" x 27" (53.3 cm x 68.6 cm)
Pastel with turpentine
German sanded pastel paper

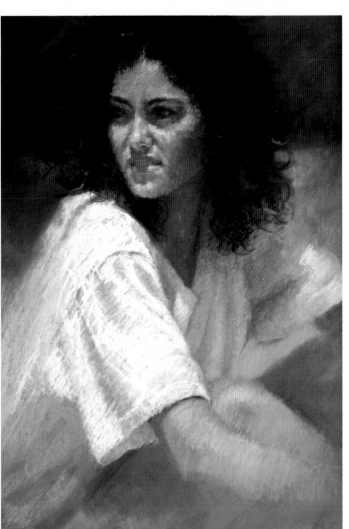

Liliane Belanger
Montreal 1953
26" x 20" (66 cm x 51 cm)
Canson Mi-Tientes

Sandra A. Johnson
Isa
36" x 28" (91.4 cm x 71.1 cm)
Pastel with turpentine
Canson pastel paper

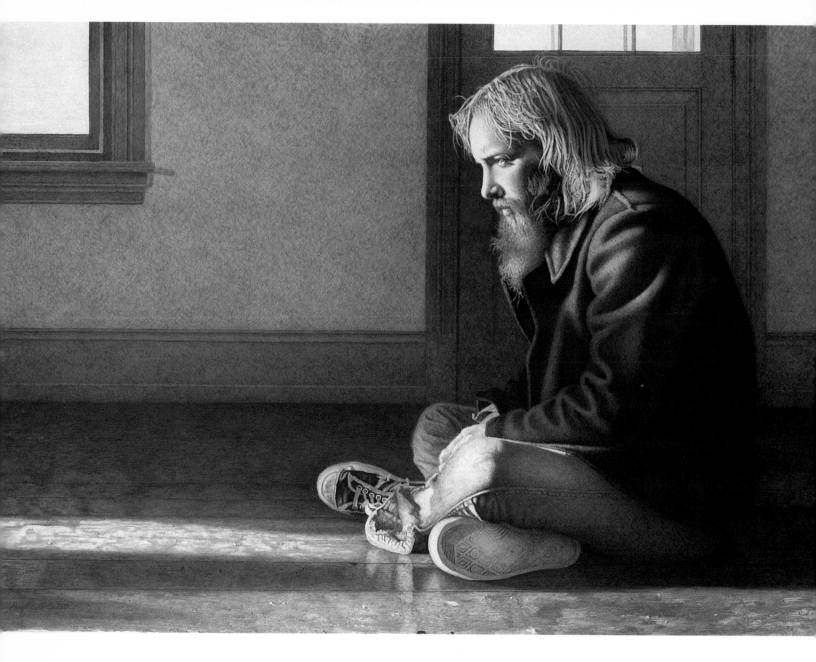

Douglas Wiltraut
Mourning Dove
28" x 42" (71 cm x 107 cm)
Masonite gesso-coated panel

Loryn Brazier
The Baptism
56" x 42" (142.2 cm x 106.7 cm)
Canvas

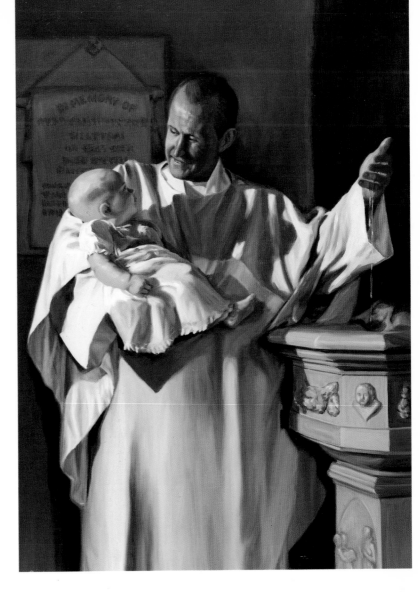

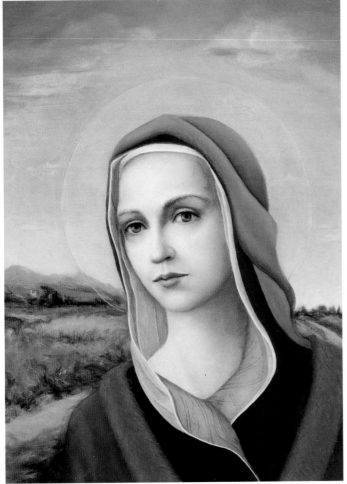

Valori Fussell
Madonna of Medjugorje
18.5" x 13.5" (45 cm x 34.3 cm)
Prepared panel

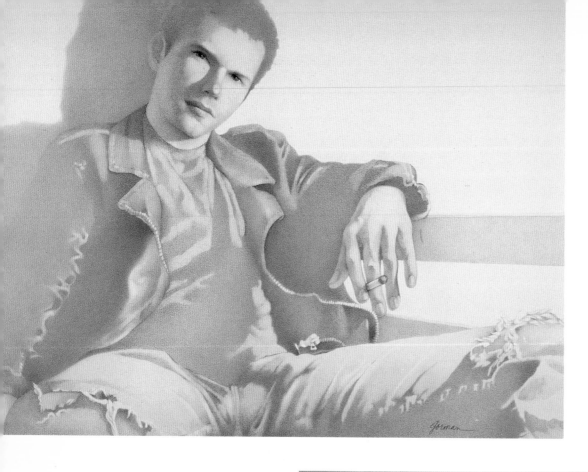

Marilyn Gorman
Rebel Without a Pause
20" x 27" (51 cm x 69 cm)

D.J. Hansen
Doin' Lunch
22" x 30" (56 cm x 76 cm)

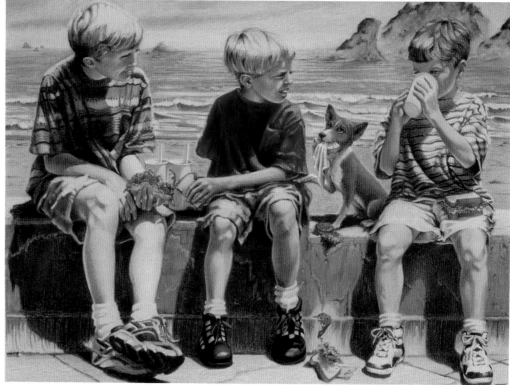

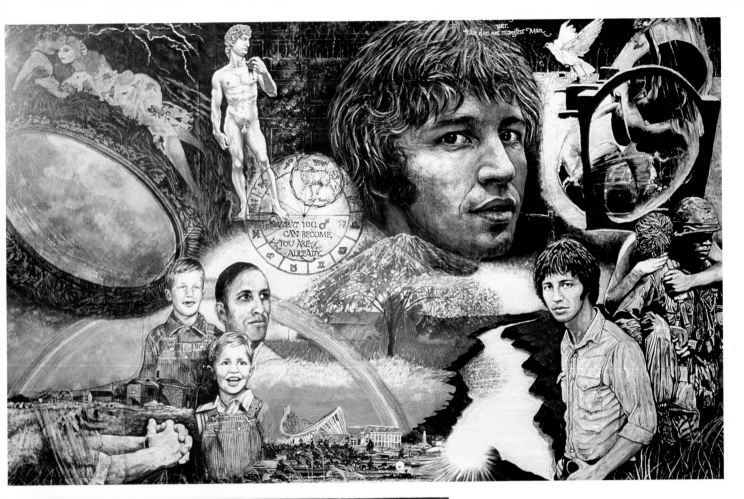

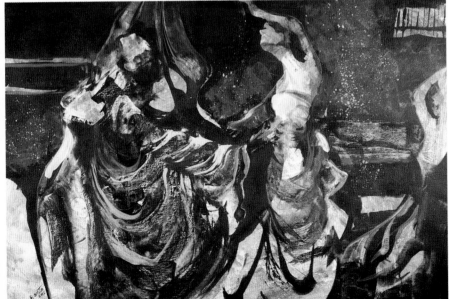

Judithe Randall
Portrait of a Life
18" x 28" (45.7 cm x 71.1 cm)
Crescent
Media: Grumbacher watercolors, Rapidograph
pen and ink, white crayon chalk

Dorothy Barta
From Whence It All Began
21" x 29" (53.3 cm x 73.7 cm)
Arches 140 lb. cold press
Media: Acrylic, gesso

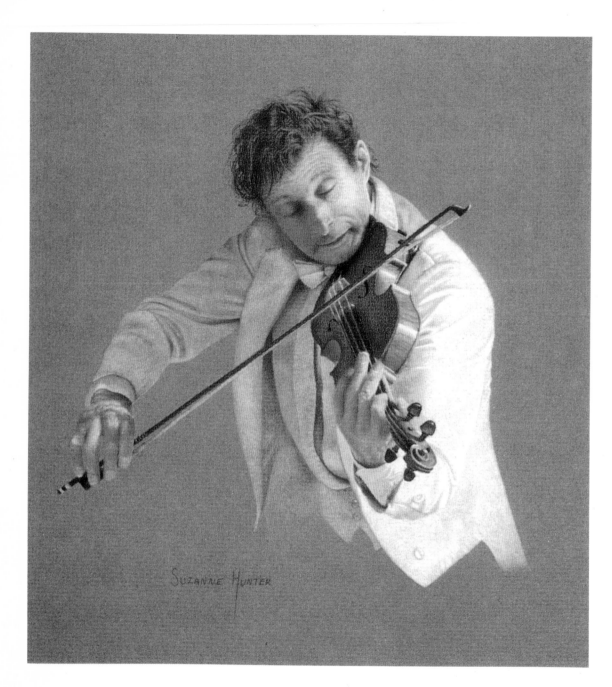

Suzanne Hunter
Ecstasy
18" x 20" (46 cm x 51 cm)
Alphamat

Charlotte Wharton
Stacy O.
24" x 20" (61 cm x 50.8 cm)
Canvas

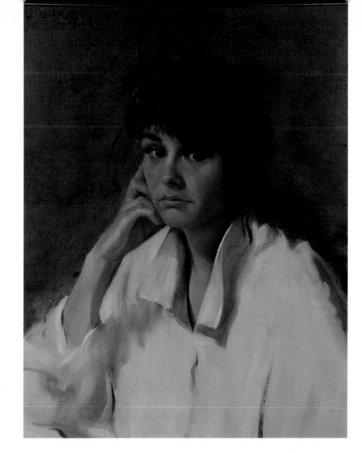

Eileen Kennedy-Dyne
Portrait of Helen Djamspun
28" x 36" (71.1 cm x 91.4 cm)
Oil with grisaille underpainting
Linen

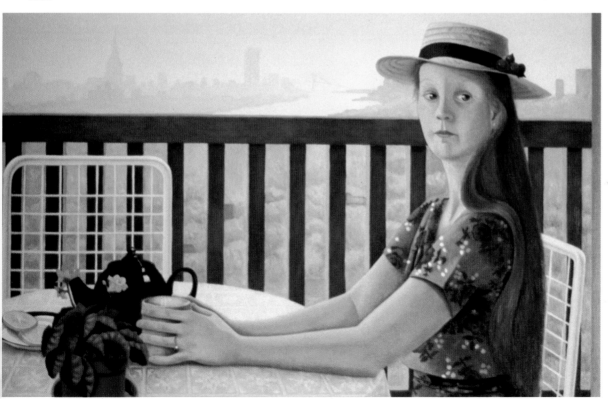

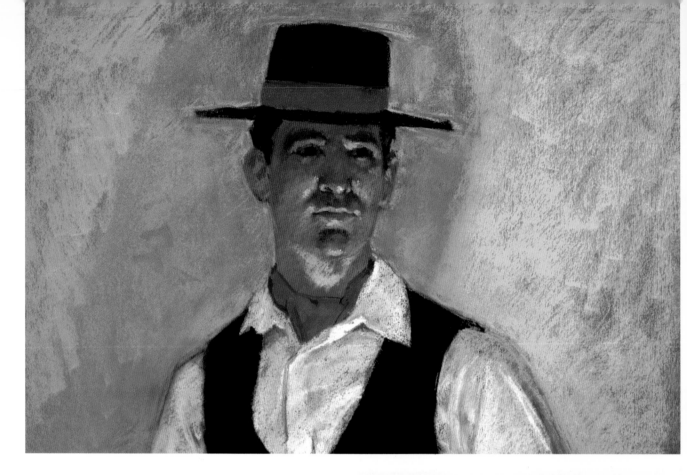

Bob Gerbracht
The Flamenco Dancer
13" x 19" (33 cm x 48.3 cm)
Canson Mi-Teintes 75 lb. paper

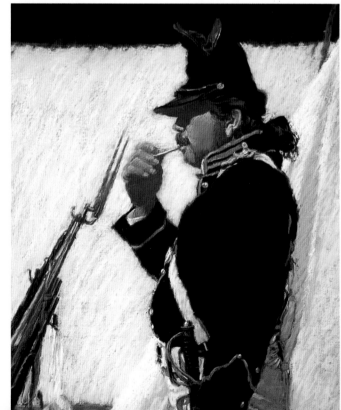

Bill James
Heritage Day
19" x 16" (48.3 cm x 40.6 cm)
Pumice board

Cathy Babcock
Douglas Torre, MD
30" x 40" (76 cm x 102 cm)

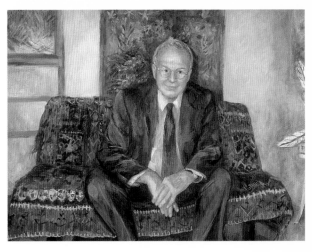

Maggie Goodwin
The Sheep Herder
16" x 20" (40 cm x 51 cm)

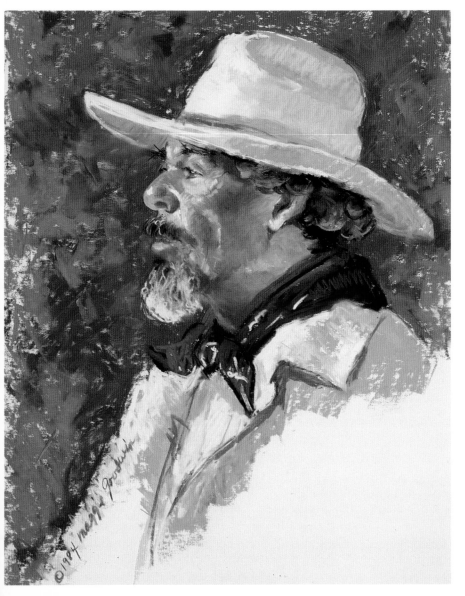

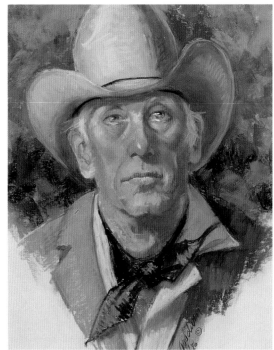

Maggie Goodwin
Luke
15" x 19" (38 cm x 48 cm)

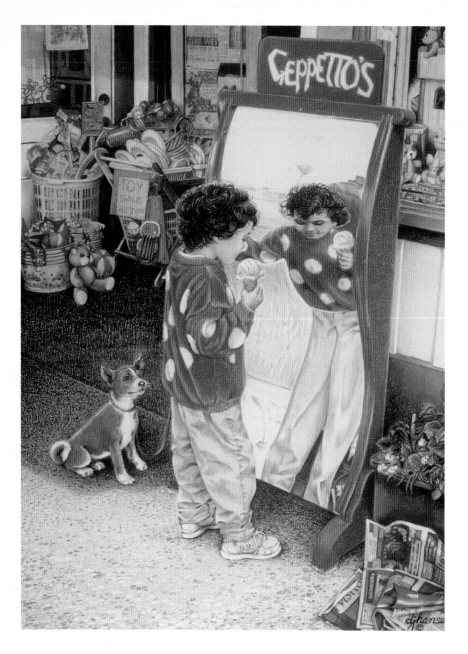

D.J. Hansen
Magic Mirror
22" x 30" (56 cm x 76 cm)

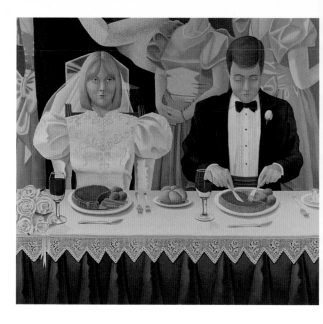

E. Kennedy-Dyne
American Wedding
48" x 52" (122 cm x 132 cm)

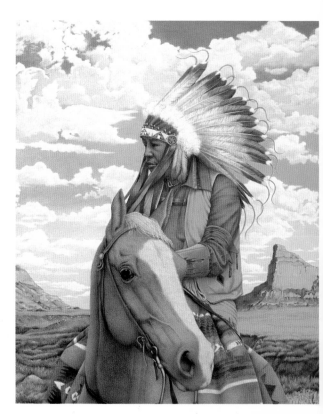

Stan Pawelczyk
My Ancestor's Hunting Grounds
22" x 18" (56 cm x 46 cm)

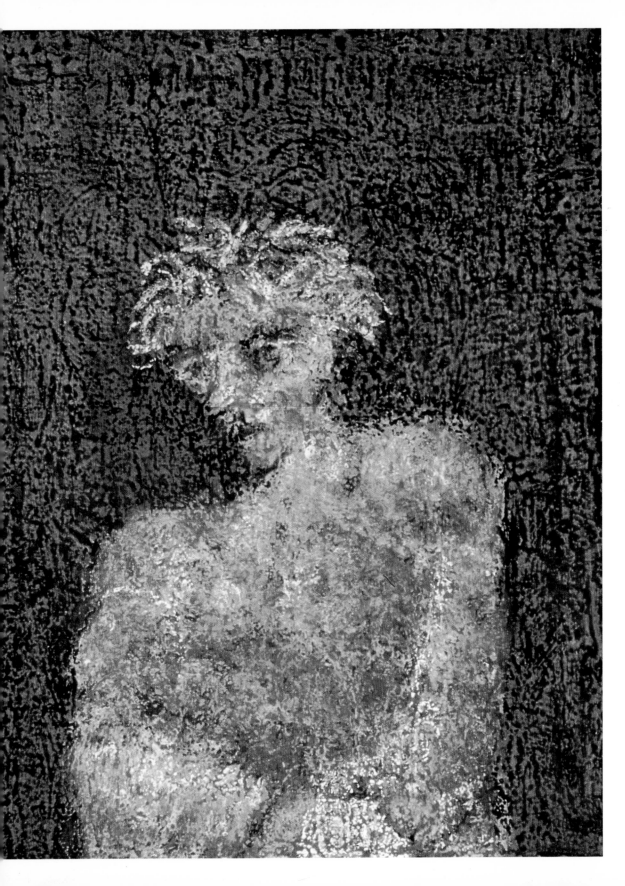

Winston Hough
Figure
24" x 19" (61 cm x 48.3 cm)
Oil with acrylic ground
Canvas

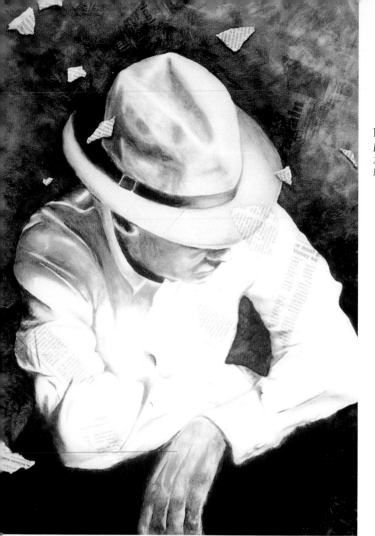

Keith Grace
Ethical Dilemma
24" x 18" (61 cm x 45.7 cm)
Heavy translucent vellum

Keith Grace
Final Scoop
24" x 18" (61 cm x 45.7 cm)
Heavy translucent vellum

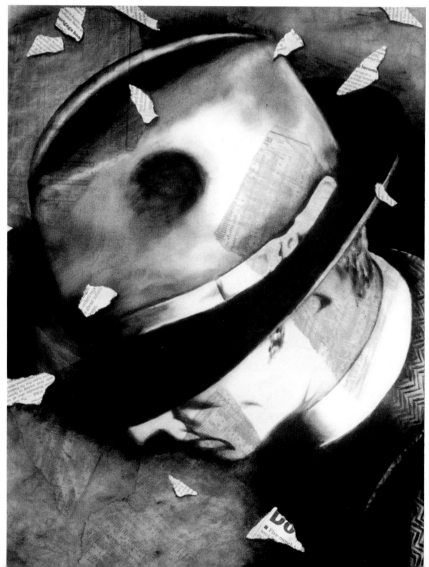

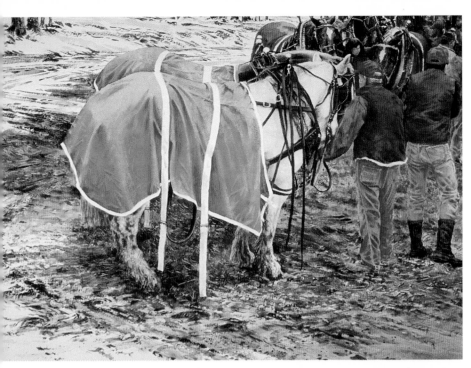

Neil Drevitson, A.W.S.
Teamsters
22" x 30" (55.9 cm x 76.2 cm)
Waterford 300 lb. cold press

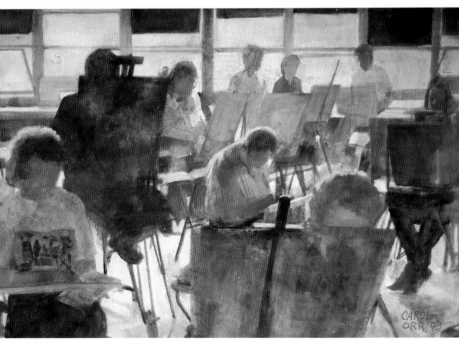

Carol Orr, A.W.S., N.W.S.
Classroom Situation
17" x 28" (43.2 cm x 71.1 cm)
260 lb. Winsor & Newton rough
Media: Gesso, underpainting splashes,
watercolor with gesso.

Lael Nelson
High cotton
31" x 19" (78.7 cm x 48.3 cm)
Cold press

Alexander C. Piccirillo
Three Part Harmony
62" x 40" (157.5 cm x 101.6 cm)
Pastel with gesso and ground pumice stone
Triple-weight cold press illustration board

Alexander C. Piccirillo
The Effigy
65" x 45" (165.1 cm x 114.3 cm)
Pastel with gesso and ground pumice stone
Luan plywood

D. Wels
The Smoker
44" x 60" (112 cm x 152 cm)
Canvas

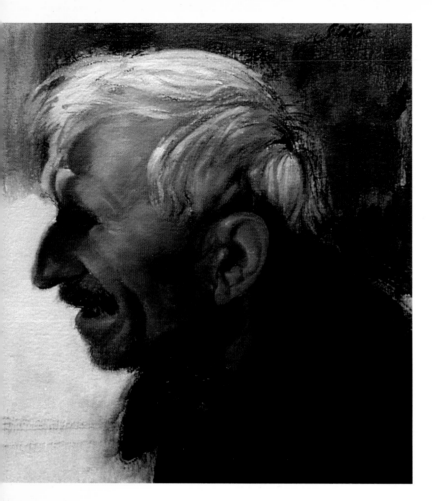

Nick Scalise
Old Man Talking, Profile, Russia
9" x 8.5" (22.2 cm x 21.6 cm)
Illustration board

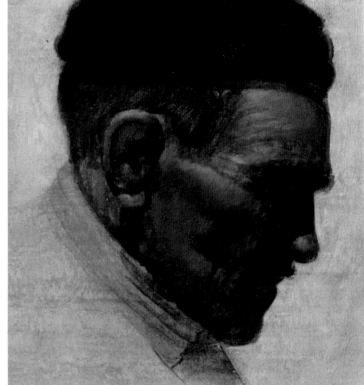

Nick Scalise
Study, Man with Cap, Profile, Italy
9" x 7" (22.9 cm x 17.8 cm)
Illustration board

Atanas Karpeles
Repose
30" x 23" (76 cm x 59 cm)
Acrylic with pastel
Arches 300 lb. paper

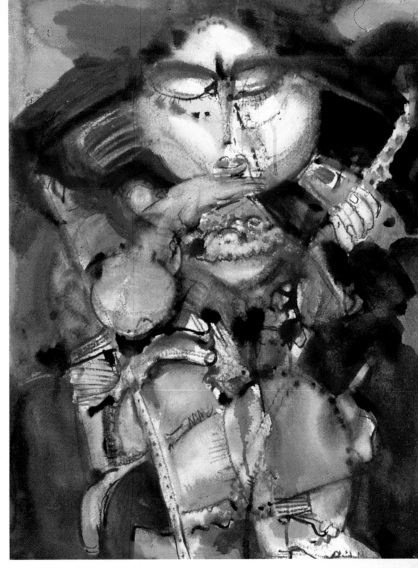

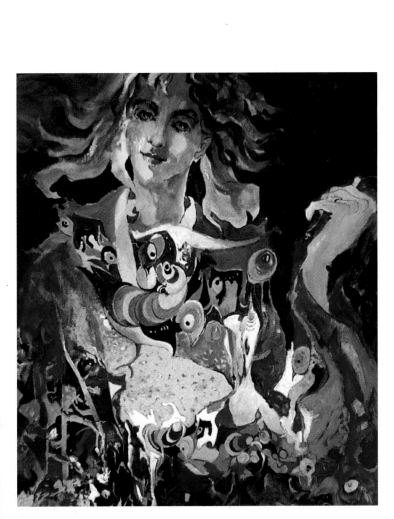

Robert Lamell
Pythia
30" x 24" (78 cm x 61 cm)
Canvas

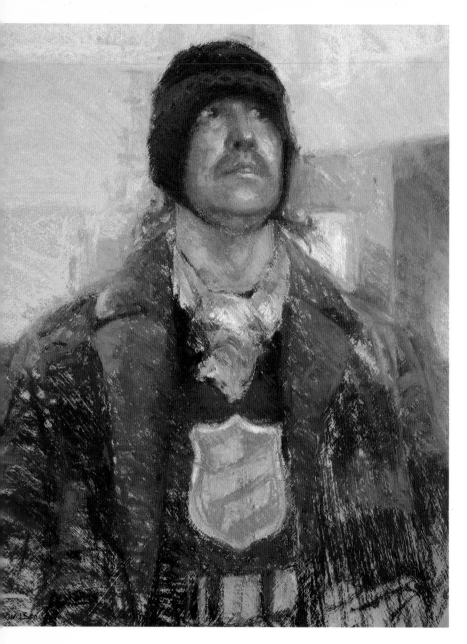

Doug Dawson
Private in the Salvation Army
25" x 20" (63.5 cm x 50.8 cm)
Masonite board

Nicholas Sacripante
Rose II
30" x 24" (76.2 cm x 61 cm)
Canson paper

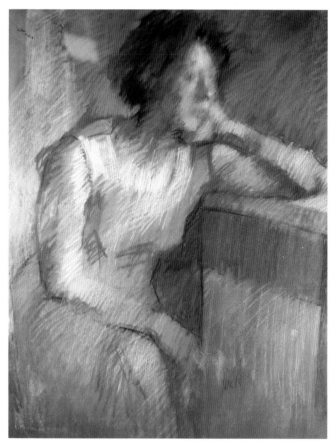

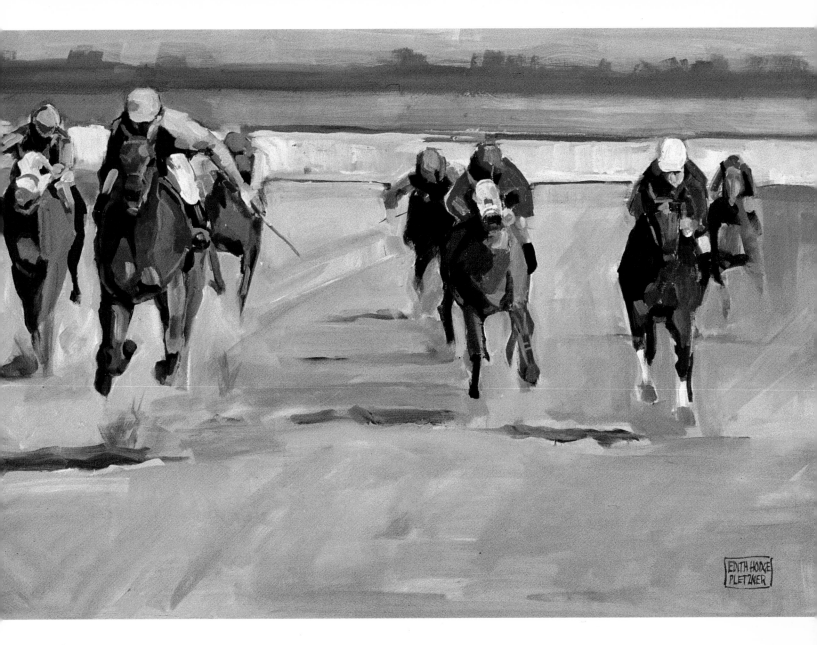

Edith Hodge Pletzner
Home Stretch
24" x 36" (61 cm x 91 cm)
Canvas

Patrick Fiore
Untitled
10" x 7" (25 cm x 18 cm)
Canvas mounted on board

Nancy Gawron
Brian and the Ball
14" x 17" (36 cm x 43 cm)
Crescent mat board 1605

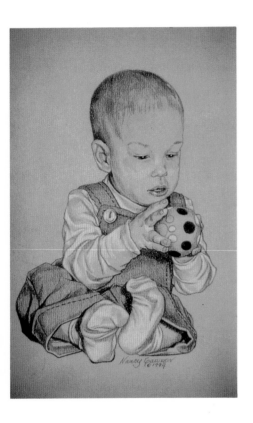

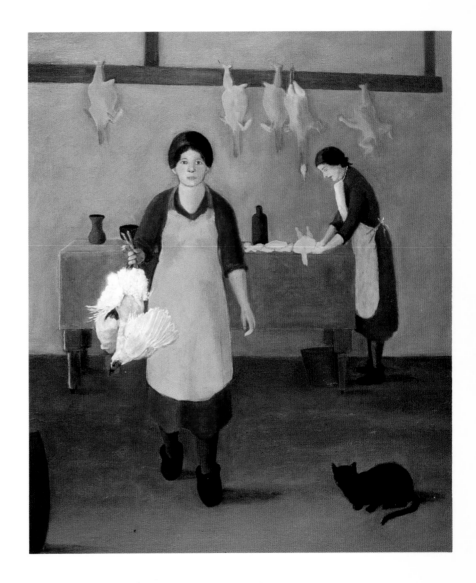

Eva Martino
Chicken House IV
22" x 19" (55.9 cm x 48.3 cm)
Linen canvas

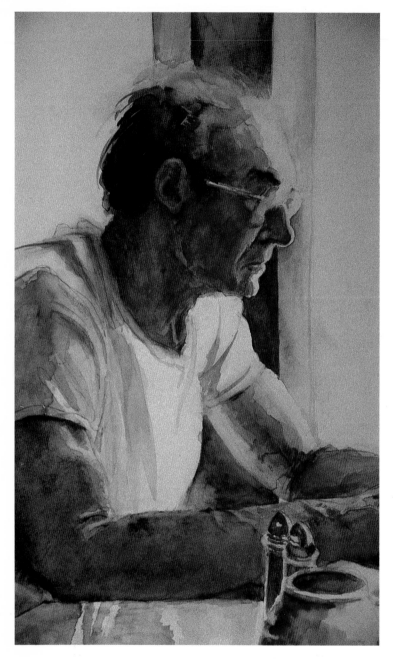

Ron Tirpak
Untitled
13.5" x 10" (34.3 cm x 25.4 cm)
Bristol 2-ply plate

Mildred Bartee
Sunny
21.25" x 28.5" (53.9 cm x 72.4 cm)
Fabriano Artistico 140 lb. smooth

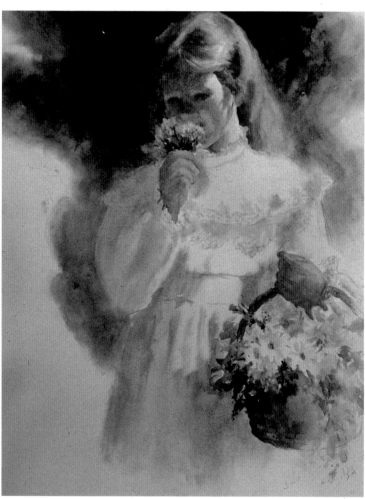

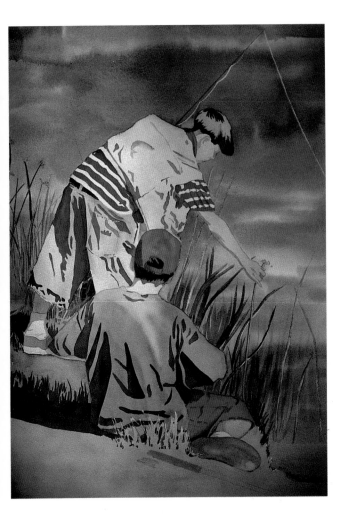

Paula B. Hudson
Ancient Pasttimes II
22" x 33" (55.9 cm x 83.8 cm)
Lana Aquarelle 300 lb.

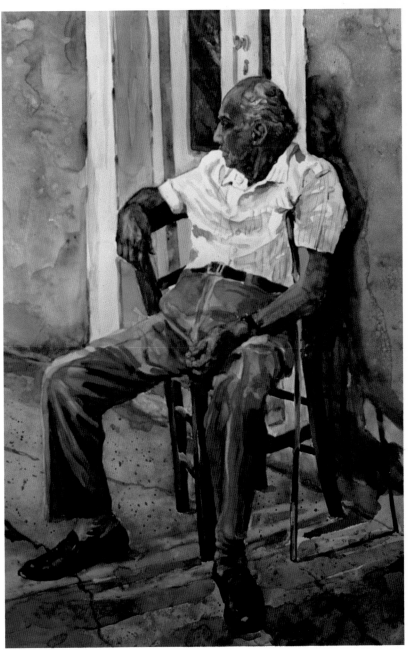

Elizabeth H. Pratt
Sunday Afternoon
28" x 22" (71.1 cm x 55.9 cm)
Strathmore 3-ply

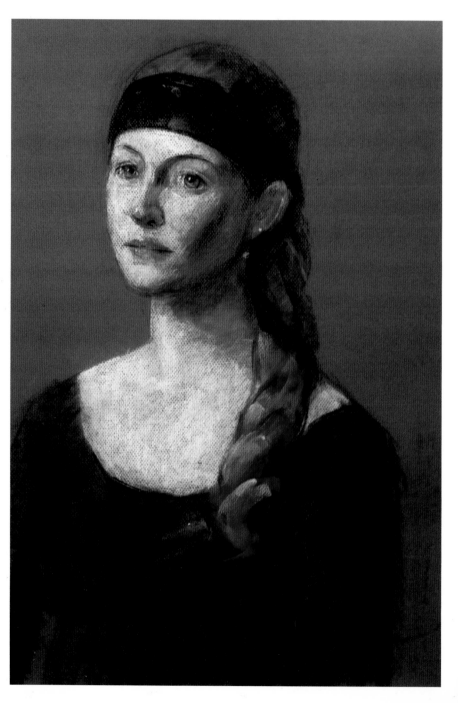

Thomas J. Strickland
Debbie
25" x 19" (63.5 cm x 48.3 cm)
Canson Mi-Teintes paper

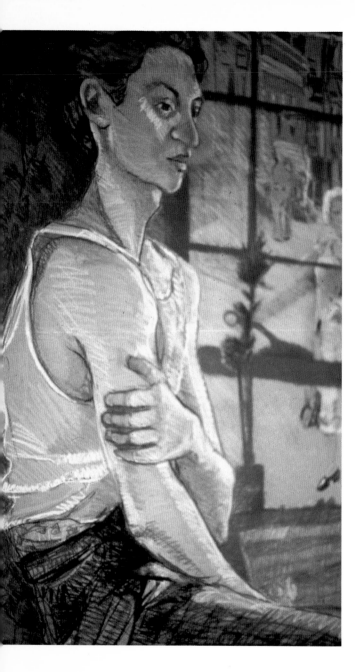

N. Marino D'Alessio
And My Aunt Betty's Dog Died!
60" x 32" (152.4 cm x 81.3 cm)
Canson Mi-Teintes high rag content acid-free
75 lb. pastel roll

Linda Greene
Deep Thought
17" x 23" (43 cm x 58 cm)
Mat board

Kenneth Hershenson
Portrait of the Artist
26" x 23" (66 cm x 58 cm)
Rising Stonehenge

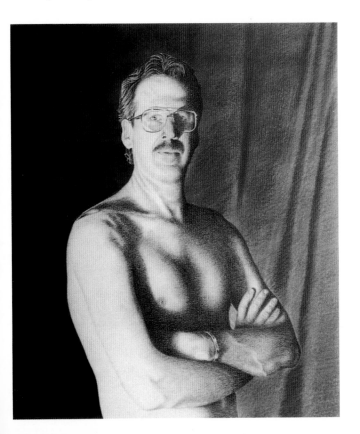

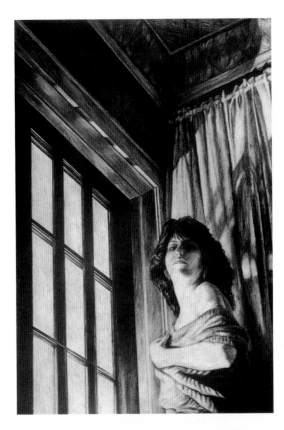

Tracy D. Snowman
Self-Portrait
22" x 30" (56 cm x 76 cm)
*Crescent cold press
illustration board*

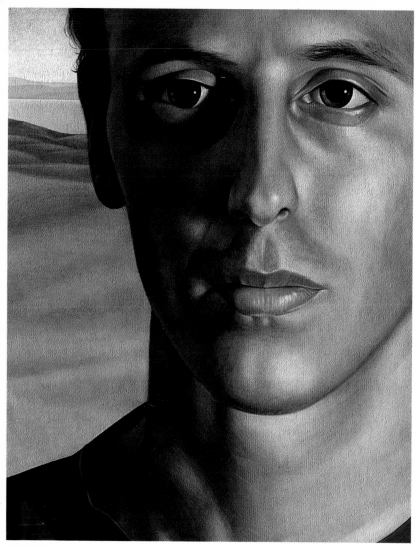

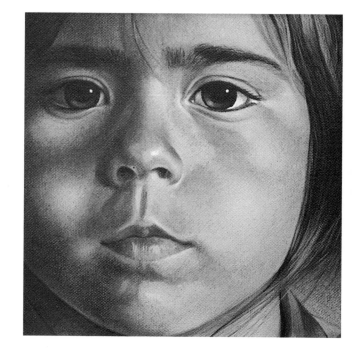

Patrick Fiore
Ana
6" x 6" (15 cm x 15 cm)
Canvas mounted on board

Patrick Fiore
Yaron Inbar
20" x 16" (51 cm x 41 cm)
Canvas mounted on board

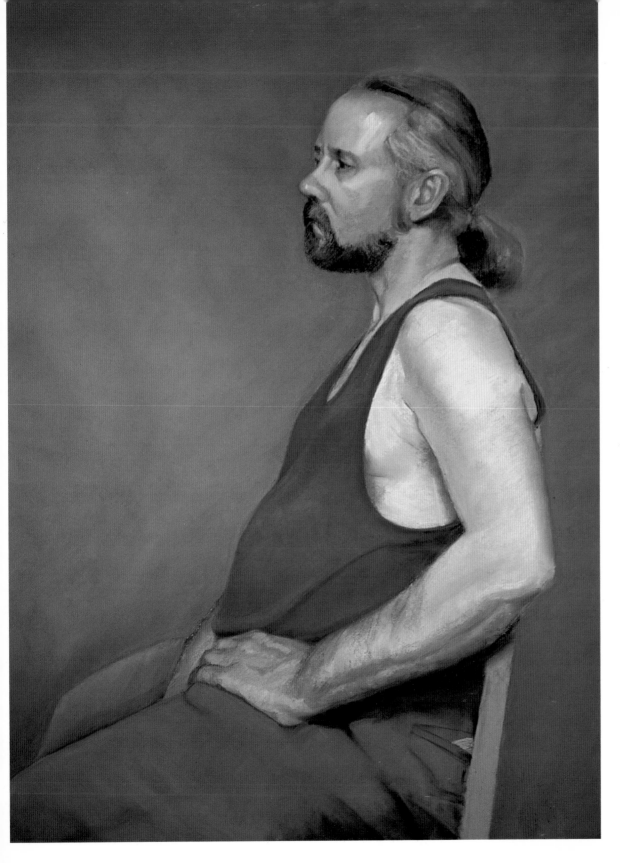

Diana De Santis
Marshall
36" x 28" (91.4 cm x 71.1 cm)
Gesso-primed Arches 4-ply board

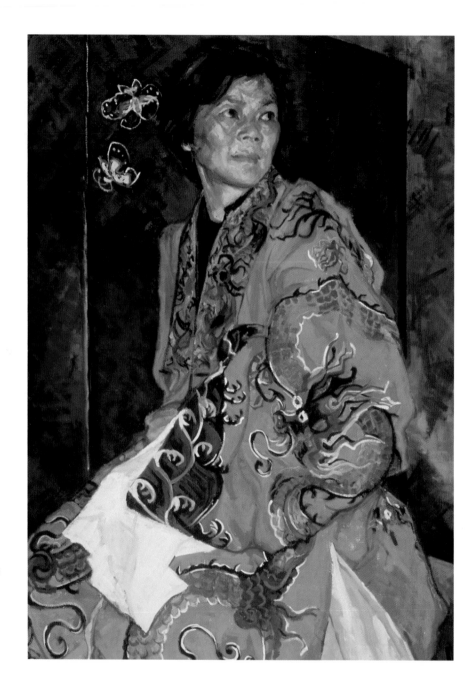

Lucille T. Stillman
Madame Butterfly
48" x 38" (121.9 cm x 96.5 cm)
Linen canvas

Thomas V. Trausch
In Passing
26" x 20" (66 cm x 50.8 cm)
Arches 140 lb. hot press

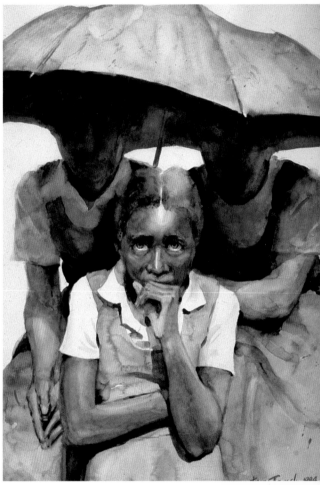

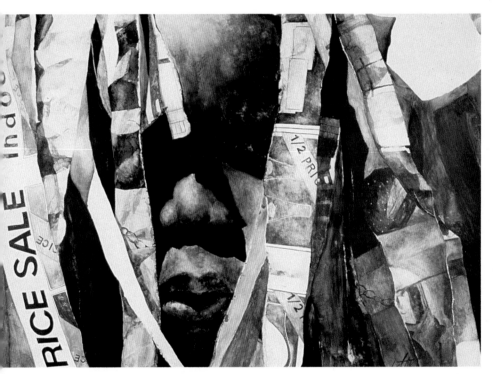

S.J. Hart
Nathaniel
40" x 60" (101.6 cm x 152.4 cm)
Foam core

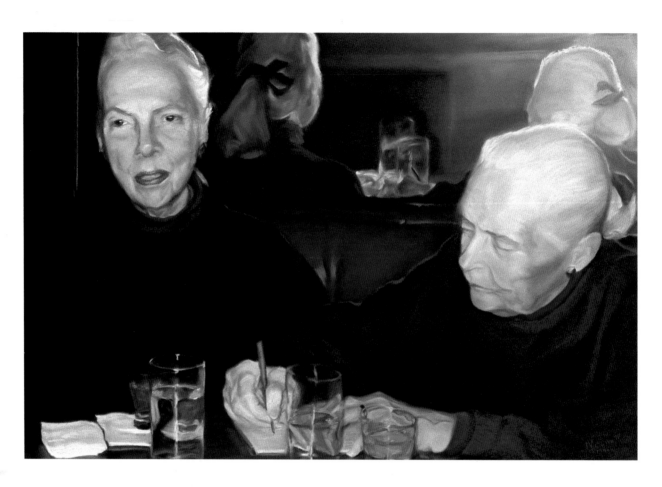

Jeanette V. Collett
Memoirs
24" x 36" (61 cm x 91.4 cm)
Marble-dust treated Windberg
masonite panel

Barry G. Pitts
Storyteller in White
31" x 17.5" (78.7 cm x 44.5 cm)
Sanded board

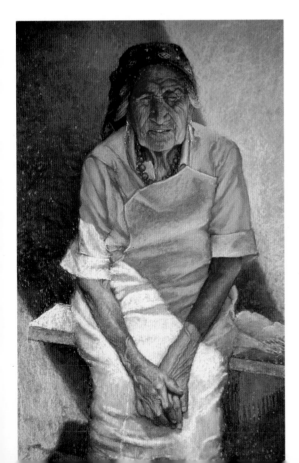

Mary Hargrave
The Fisherman's Widow, Navare, Portugal
23" x 17" (58.4 cm x 43.2 cm)
Canson Mi-Teintes paper

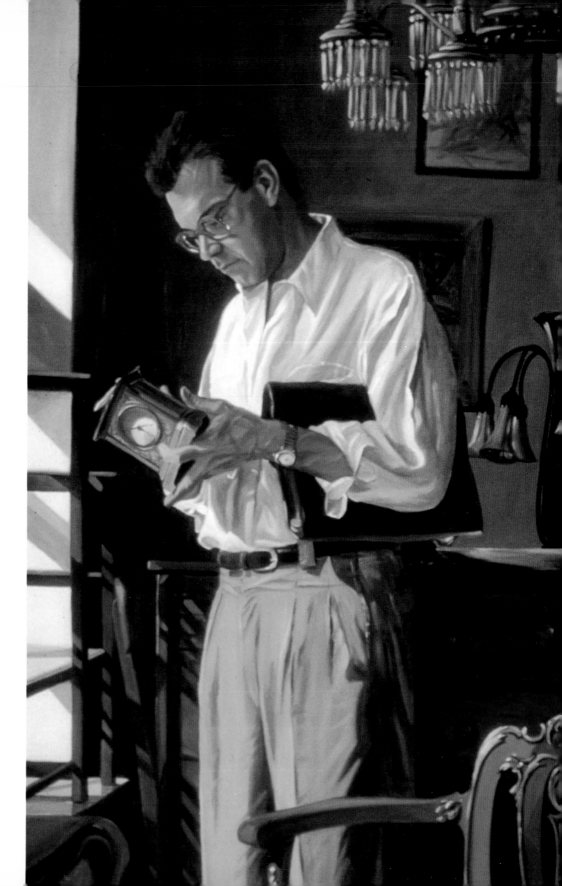

Loryn Brazier
The Collector
60" x 36" (152.4 cm x 91.4 cm)
Canvas

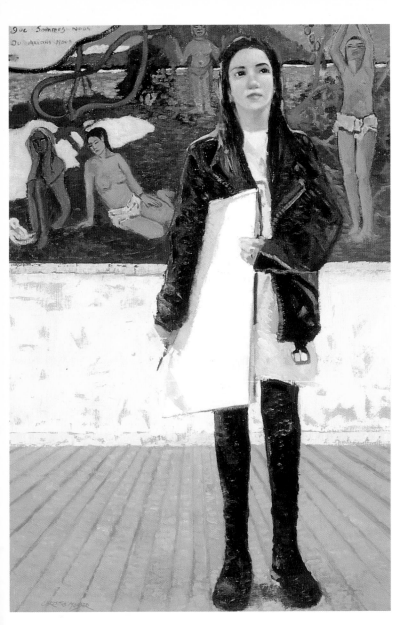

Christine Mosher
Daydream Believer
28" x 22" (71.1 cm x 55.9 cm)
Linen canvas

Edith Hodge Pletzner
Migrant Family
24" x 18" (61 cm x 46 cm)
Canvas

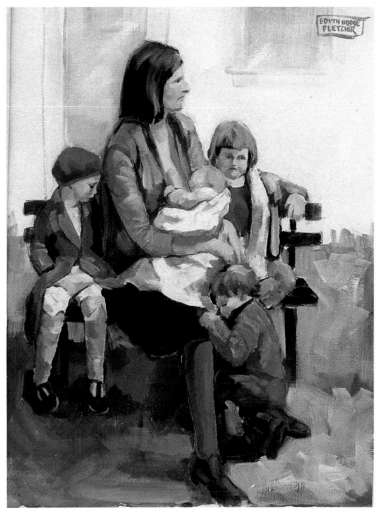

83

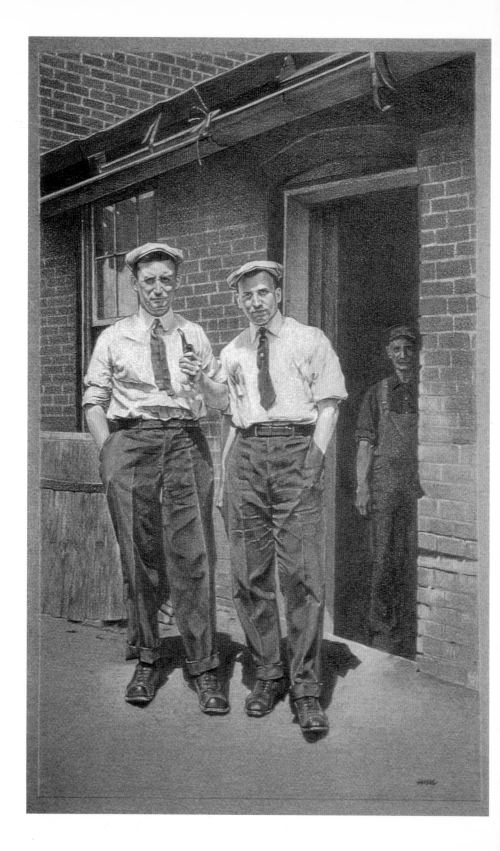

Cynthia Samul
Mac Still on the Job
17" x 10" (43 cm x 25 cm)
Canson Mi-Tientes

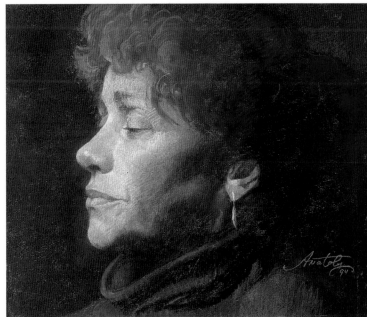

Anatoly Dverin
Clementine
15.5" x 19.5" (39.4 cm x 49.5 cm)
Canson Ingres pastel paper, tint #55

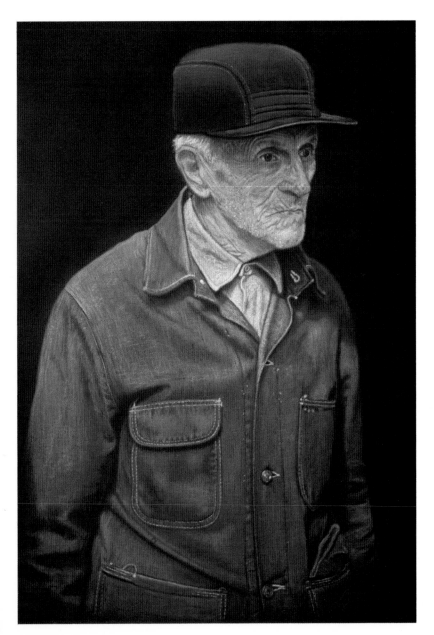

James E. Welch
Lee of Hartland
30" x 24" (76.2 cm x 61 cm)
Acid-free heavyweight paper

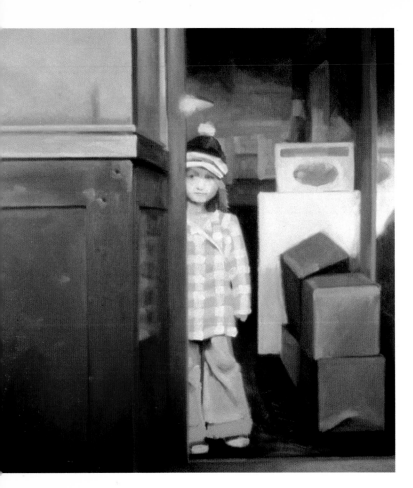

Katherine Reaves
Easter
40" x 36" (101.6 cm x 91.4 cm)
Canvas

Katherine Reaves
Green Hat
42" x 42" (106.7 cm x 106.7 cm)
Canvas

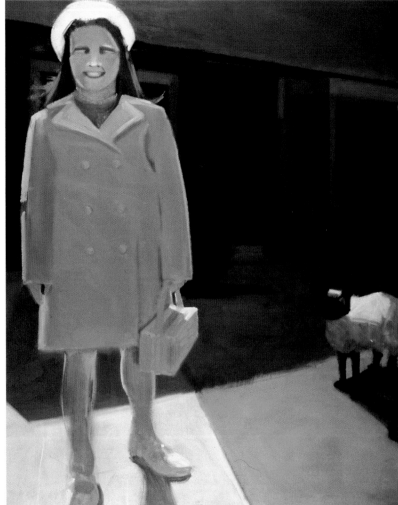

Joanna Calabro
Mask Maker, Venice
24" x 36" (61 cm x 76.2 cm)
Linen canvas

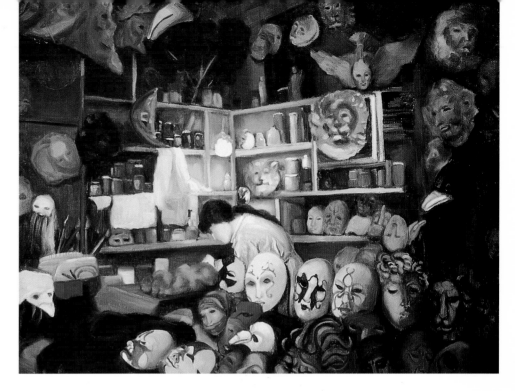

Eileen Kennedy-Dyne
Snakes and Ladders
48" x 68" (121.9 cm x 172.7 cm)
Canvas

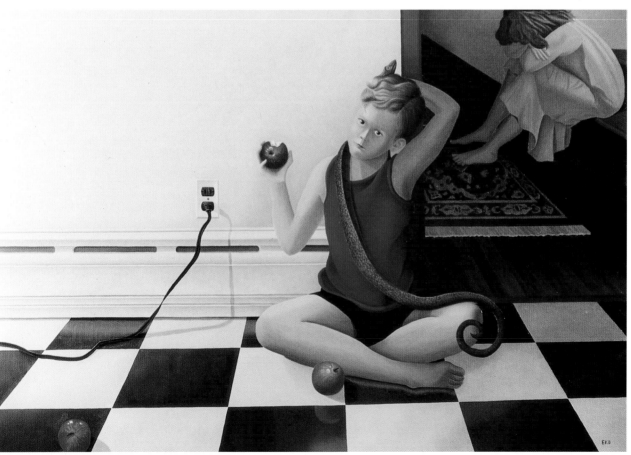

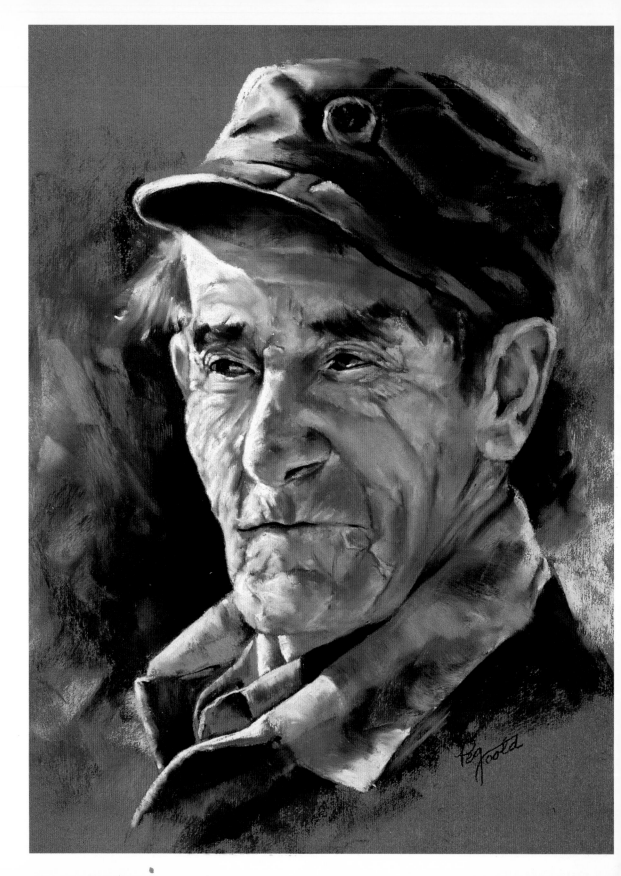

Peggy Ann Solinsky
Romero
19.5" x 16.5" (49.5 cm x 41.9 cm)
Sanded board

Kim Seng Ong, A.W.S.
Gyantse Market
21.5" x 30" (54.6 cm x 76.2 cm)
Arches 850 G/M2 rough

Edwin C. Shuttleworth, M.D.
Inner City #3
21.5" x 29.5" (54.6 cm x 75 cm)
Arches 140 lb. cold press

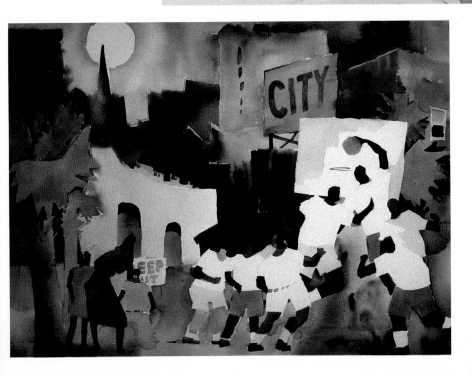

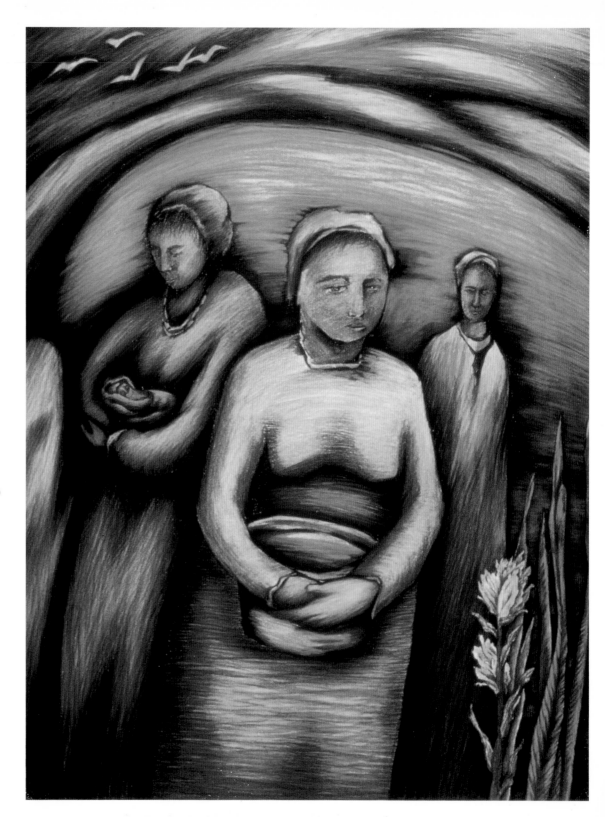

Carolyn Reed
Collecting Water
27" x 22" (69 cm x 56 cm)
Rives BFK paper

Christine F. Atkins
Dried Flower Market, Brisbane
22" x 31" (55.9 cm x 78.7 cm)
Canvas

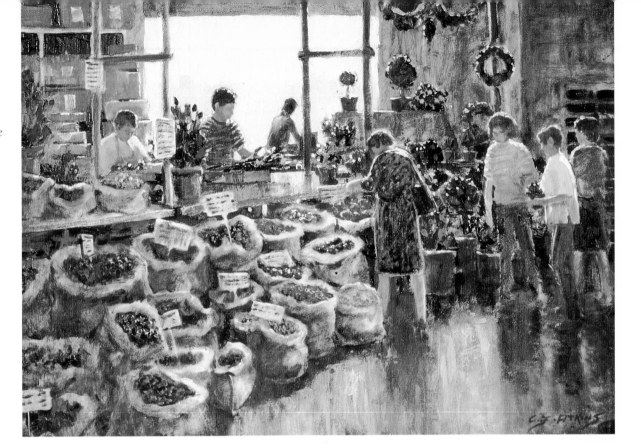

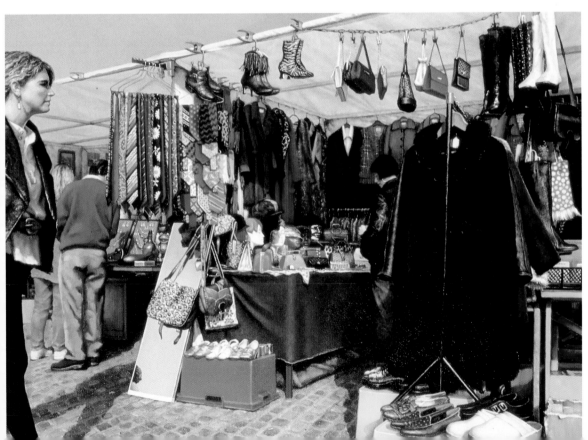

Gretchen H. Warren
Sunday Shopping
30" x 40" (76.2 cm x 101.6 cm)
Canvas

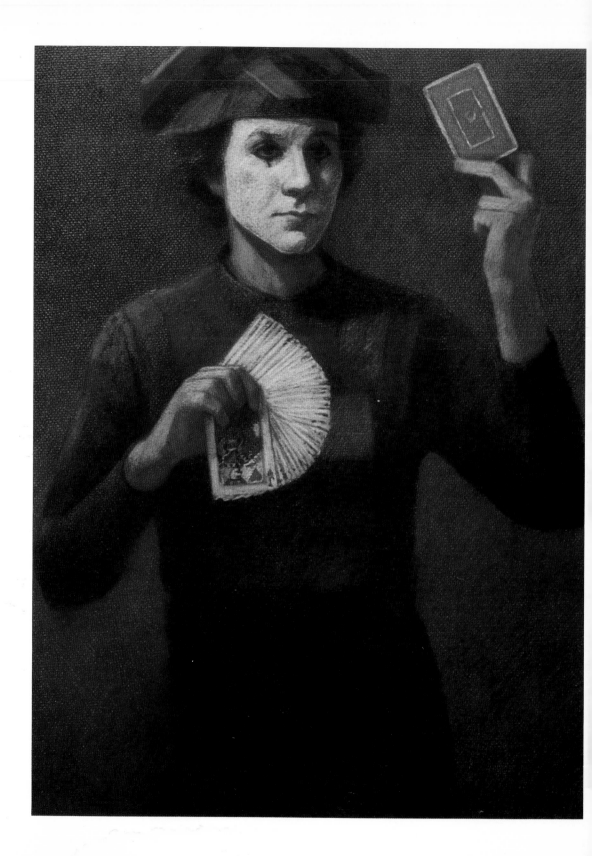

Rita Mach Skoczen
The Card Trick
33" x 26" (84 cm x 66 cm)
Canson Mi-Tientes

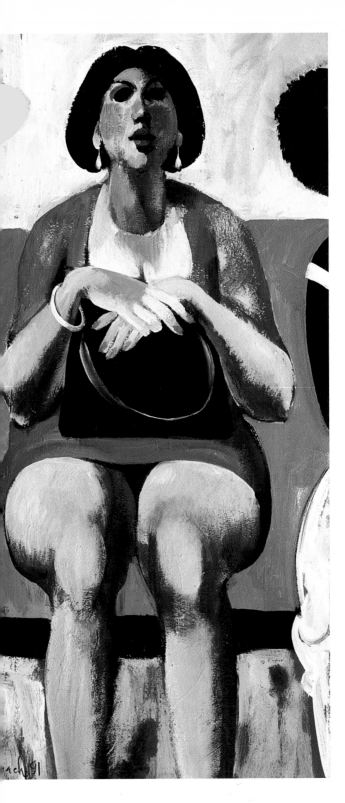

Serge Hollerbach
Woman in Green Dress
40" x 20" (102 cm x 51 cm)
*Paper on cold press
illustration board*

Serge Hollerbach
Two Women and Child
33" x 26" (84 cm x 66 cm)
*Paper on cold-press
illustration board*

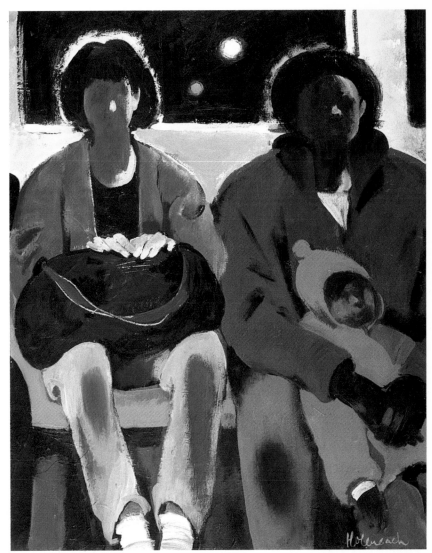

Directory & Index

Christine F. Atkins 91
154 Minimine Street
Stafford, Brisbane
Queensland 4053
Australia

Bonnie Auten 49
213 East Chicago Boulevard
Tecumseh, MI 49286

Cathy Babcock 20
122 Rowayton Avenue
Rowayton, CT 06853

Carol Baker 7, 59
32661 Pearl Dr
Fort Bragg, CA 95437

Joann A. Ballinger 14
225 Lake Road
Bozran, CT 06334

Robert L. Barnum 46
9739 Calgary Drive
Stanwood, MI 49346

Dorothy Barta 55
3151 Chapel Downs Drive
Dallas, TX 75229

Mildred Bartee 72
34 Cary Avenue
Lexington, MA 02173

Donna Basile 36
P. O. Box 97
Scituate, MA 02066

Linda Baxter 49
13826 S Meyer Rd # 2122
Oregon City, OR 97045

Liliane Belanger 51
452 Rue Dieppe
Ste-Jolie QB J3E 1C9
Canada

Michele K. Blate 11 25
1351 Lorrell Ave SW
N. Canton, OH 44720

Kim Stanley Bonar 46
9870 Van Dyke
Dallas, TX 75218

Loryn Brazier 53, 82
1904 Hanover Avenue
Richmond, VA 23220

Jane Bregoli 28
401 State Road
Dartmouth, MA 02747

Pat Cairns 17
4895 El Verano
Atascadero, CA 93422

Joanna Calabro 87
32 Main Street
Rockport, MA 01966

Gordon Carlisle 40
P. O. Box 464
Portsmouth, NH 03802-0464

Jeanette V. Collett 80
8880 South Ocean Drive, Apt. 102
Jensen Beach, FL 34957

N. Marino D'Alessio 74
P. O. Box 225
Springfield, NJ 07081

Dr. Christine J. Davis 14
1071 River Rd
Greer, SC 29651-8197

Doug Dawson 68
8622 West 44th Place
Wheat Ridge, CO 80033

Leslie B. De Mille 27
50 Cathedral Lane
Sedona, AZ 86336

Diana De Santis 38, 43, 77
34 School Street
East Williston, NY 11596

Mikki R. Dillon 30
662 Dorsey Circle
Lilburn, GA 30247

J. Everett Draper 9
20 Ponte Vedra Circle, P.O. Box 12
Ponte Vedra Beach, FL 32004

Neil Drevitson 63
Church Hill Road, P.O. Box 515
Woodstock, VT 05091

Anatoly Dverin 85
9 Oak Drive
Plainville, MA 02762

Jerry M. Ellis 41
Route 1, Box 382
Carthage, MO 64836

Lilienne B. Emrich 10
3215 North Tacoma Street
Arlington, VA 22213

Tim Ernst 30
Maison Ishikawa B-302
16-26 Yabase Shinkawamukai
Akita-shi Akita-Ken 010
Japan

Patrick Fiore 70, 76
4845 Winchester Drive
Sarasota, FL 34234

Tim Flanagan 37
Rural Route 1, Box 999
East Holden, ME 04429

Michael Frary 32
3409 Spanish Oak Drive
Austin, TX 78731

Karen Frey 17
1781 Brandon Street
Oakland, CA 94611

Valori Fussell 53
P. O. Box 2214
El Prado, NM 87529

Nancy Gawron 71
32 Delaware Ave
Red Bank, NJ 07701

Bob Gerbracht 58
1301 Blue Oak Court
Pinole, CA 94564

Rolland Golden 29
78207 Woods Hole Lane
Folsom, LA 70437

Beatrice Goldfine 35
1424 Melrose Avenue
Elkins Park, PA 19027

Maggie Goodwin 26, 59
2981 North Lakeridge Trai
Boulder, CO 803021

Marilyn Gorman 54
739 Lakeview Avenue
Birmingham, MI 48009

Keith Grace 62
3204 North View Road
Rockford, IL 61107

Irwin Greenberg 17
17 W. 67th Street
New York, NY 10023

Linda Greene 75
10081 Navarre Rd SW
Navarre, OH 44662

Joseph E. Grey II 25
19100 Beverly Road
Beverly Hills, MI 48025-3901

Christine Hanlon 22
P. O. Box 9852
San Rafael, CA 94912-9852

D.J. Hansen 36, 54, 60
3147 Dolbeer Street #18
Eureka, CA 95503

Mary Hargrave 81
6 Colonial Avenue
Larchmont, NY 10538

S.J. Hart 79
1021 Ogden #4
Denver, CO 80218

Kenneth Hershenson 75
20302 102nd Avenue SE
Kent, WA 98031

Serge Hollerbach 93
304 West 75th Street
New York, NY 10023

Winston Hough 61
937 Echo Lane
Glenview, IL 60025

Paula B. Hudson 73
24364 Paragon Place
Golden, CO 80401

Suzanne Hunter 56
6752 Fiesta Drive
El Paso, TX 79912

Linda Hutchinson 45
1784 Tallmadge Road
Kent, OH 44240

Alice Bach Hyde 6
110 Ichabod Trail
Longwood, FL 32750

Bill James 12,18, 20, 58
15840 SW 79th Court
Miami, FL 33157

George James 21
340 Colleen
Costa Mesa, CA 92627

Debra Reid Jenkins 23
14200 Thompson Drive
Lowell, MI 49331

Sandra A. Johnson 39, 51
3550 Hawk Drive
Melbourne, FL 32935

Atanas Karpeles 67
2033 East Casa Grande Street
Pasadena, CA 91104

Eileen Kennedy-Dyne 57, 60, 87
26 Spring Street
Freehold, NJ 07728

Robert Lamell 67
2640 W. Wilshire Boulevard
Oklahoma City, OK 73116

Ellen Westendorf Lane 19
2265 E. Little Las Flores Road
Topanga, CA 90290

A. M. Lawtey 40
P. O. Box 5219
Edgartown, MA 02539

Toni Lindahl 31
2120 New Garden Road
Greensboro, NC 27410

Petr Liska 29
13410 Keating Court
Rockville, MD 20853

John L. Loughlin 9
124 Angell Road
Lincoln, RI 02865

Joseph Manning 21
5745 Pine Terrace
Plantation, FL 33317-1326

Eva Martino 71
1435 Manor Lane
Blue Bell, PA 19422

Jeanette Martone 44
47 Summerfield Court
Deer Park, NY 11729

Ann James Massey 33
4, rue Auguste Chabrieres
75015 Paris
France

Anita Meynig 32
6335 Brookshire Drive
Dallas, TX 75230-4017

Lance R. Miyamoto 28
53 Smithfield Road
Waldwick, NJ 07463

Christine Mosher 83
13 Main Street
Rockport, MA 01966

Melissa Miller Nece 13
2245-D Alden Lane
Palm Harbor, FL 34683-2533

Lael Nelson 63
600 Lake Shore Drive
Scroggins, TX 75480

Bart O'Farrell 15
Treleague Farm St. Keverne
Helston, Cornwall TR12 6PQ
United Kingdom

Desmond O'Hagan 6, 16, 22
2882 South Adams Street
Denver, CO 80210

Kim Seng Ong 89
Block 522, Hougang Avenue 6 #10-27
Singapore 1953

Carol Orr 63
Box 371
La Conner, WA 98257

Parima Parineh 35
20978 Sara View Court
Saratoga, CA 95070

Stan Pawelczyk 60
306 Monroe Drive
Piedmont, SC 29673

Alexander C. Piccirillo 64
26 Vine Street
Nutley, NJ 07110-2636

Ann T. Pierce 41
545 W. Shasta Avenue
Chico, CA. 95926

Barry G. Pitts 81
P. O. Box 14526
Long Beach, CA 90803

Edith Hodge Pletzner 42, 69, 83
221 Rose Street
Metuchen, NJ 08840

Elizabeth H. Pratt 73
P. O. Box 238
Eastham, MA 02642

Judithe Randall 55
2170 Hollyridge Drive
Hollywood, CA 90068

Katherine Reaves 86
163 Exchange Street, #404
Pawtucket, RI 02860

Carolyn Reed 90
P. O. Box 198
Unalaska, AK 99685

Mitsuno Ishii Reedy 26
1701 Denison Drive
Norman, OK 73069

Junko Ono Rothwell 51
3625 Woodstream Circle
Atlanta, GA 30319

Nicholas Sacripante 68
9411 Moorehead Lane
Port Richey, FL 34668

Cynthia Samul 84
15 Pacific Street
New London, CT 06320

Nick Scalise 66
59 Susan Lane
Meriden, CT 06450

Edwin C. Shuttleworth 89
3216 Chapel Hill Boulevard
Boynton Beach, FL 33435

Rita Mach Skoczen 92
609 Spartan Drive
Rochester Hills, MI 48309

Dixie Smith 36
25601 16th Avenue S.
Des Moines, WA 98198

Tracy D. Snowman 75
25599 E. Middle Lake Road
Canton, IL 61520

Peggy Ann Solinsky 88
541 Monroe, Unit A
Denver, CO 80206

Colleen Newport Stevens 25
8386 Meadow Run Cove
Germantown, TN 38138

Lucille T. Stillman 18, 78
10298 N. 135th Place
Scottsdale, AZ 85259

Thomas J. Strickland 74
2595 Taluga Drive
Miami, FL 33133

Paula Temple 24
P. O. Box 1935
University, MS 38677

Janis Theodore 38
274 Beacon Street
Boston, MA 02116

Ron Tirpak 72
10541B Lakeside Drive S.
Garden Grove, CA 92840

Thomas V. Trausch 79
2403 Mustang Trail
Woodstock, IL 60098

Marvin Triguba 45
1463 Rainbow Drive NE
Lancaster, OH 43130

Bruce Backman Turner 8
4 Story Street
Rockport, MA 01966

Lawrence Wallin 34
895 Toro Canyon Road
Santa Barbara, CA 93108-1641

Gretchen H. Warren 91
1895 Bluff Street Apt. C
Boulder, CO 80304

James E. Welch 85
585 South Huron Road
Harrisville, MI 48740

Jim Wells 11, 25
5801 Woodburn Drive
Knoxville, TN 37919

D. Wels 16, 65
1726 Second Avenue
New York, NY 10128

Arne Westerman 12
711 SW Alder #313
Portland, OR 97205

Charlotte Wharton 27, 50, 57
594 Chandler Street
Worcester, MA 01602-1731

Faith Wickey 24
P.O. Box 536
Centreville, MI 49032

Douglas Wiltraut 47, 48, 52
969 Catasauqua Road
Whitehall, PA 18052

Brenda J. Woggan 45
8785 Sanbur Trail NW
Rice, MN 56367

Rhoda Yanow 10, 43
12 Korwell Circle
West Orange, NJ 07052